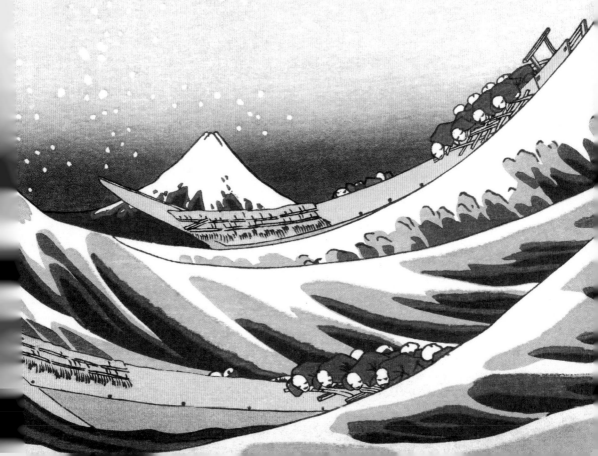

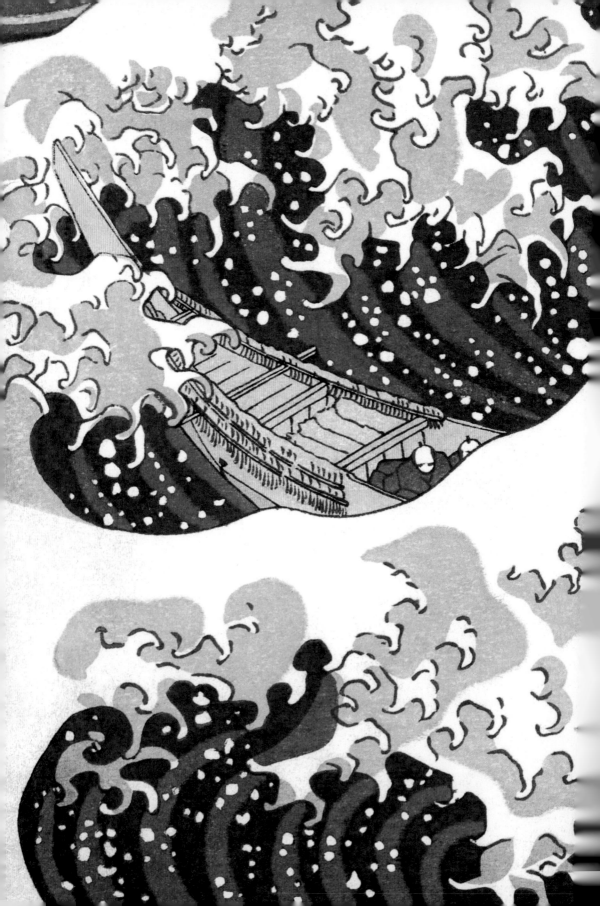

HOKUSAI

LAURENCE KING

Published by Laurence King Publishing
361–373 City Road
London EC1V 1LR
United Kingdom
Tel: +44 20 7841 6900
Email: enquiries@laurenceking.com
www.laurenceking.com

Translated from the Italian by Edward Fortes

A catalogue record for this book
is available from the British Library

ISBN: 978-1-78627-893-7

Design: Florian Michelet
Endpapers: Shawshots/Alamy

Printed in China

Laurence King Publishing is committed to ethical
and sustainable production. We are proud participants
in The Book Chain Project®.
bookchainproject.com

A Graphic Biography

GIUSEPPE LATANZA
FRANCESCO MATTEUZZI
Translation by Edward Fortes

Laurence King Publishing

MENTION THE NAME HOKUSAI AND SUDDENLY
THE ART AND COLOURS OF JAPAN, AND THE COUNTRY
ITSELF, SPRING TO MIND.

THE NAME CONJURES THE CHARM OF ELEGANT FEMALE
FIGURES, PEACEFUL NATURAL LANDSCAPES AND STRIKING
URBAN ENVIRONMENTS.

UNDER THE GREAT WAVE OFF KANAGAWA, A WOODBLOCK
PRINT HE CREATED AROUND 1830, IS ONE OF THE MOST
FAMOUS IMAGES EVER MADE, AND IMPRESSIONS OF
IT ARE PRESERVED IN SOME OF THE WORLD'S MOST
PRESTIGIOUS MUSEUMS.

BUT WHO WAS HOKUSAI?
AND HOW DID HE COME
TO SYMBOLIZE JAPANESE ART?
HIS STORY BEGINS IN EDO,
THE LARGEST CITY IN JAPAN
– AND INDEED, AT THE
TIME, THE WORLD...

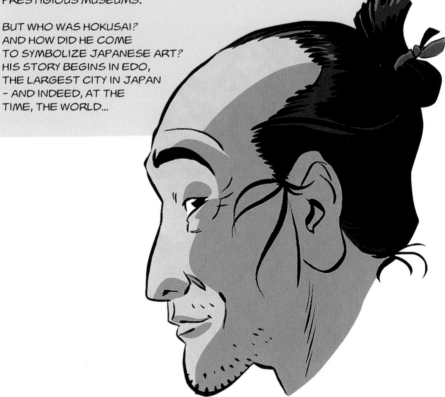

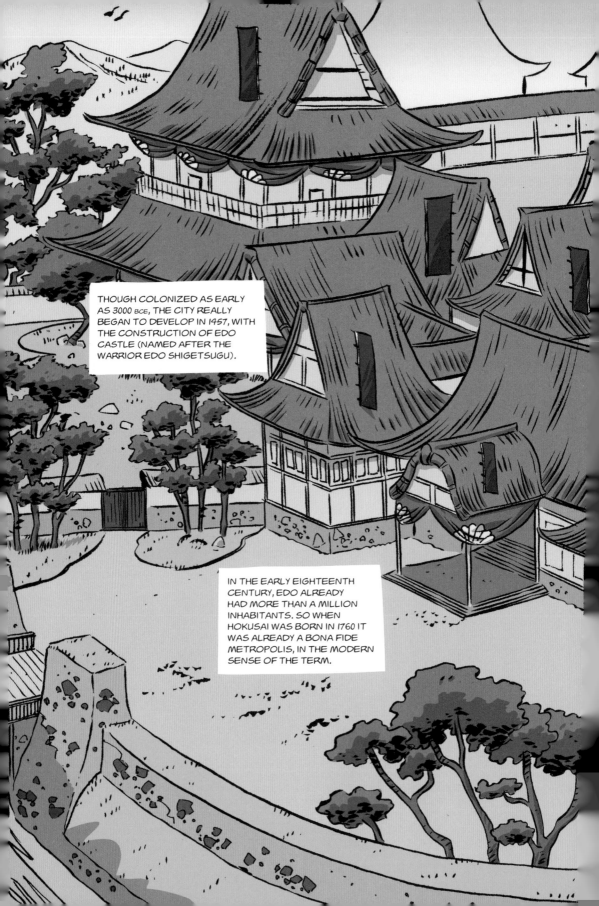

THOUGH COLONIZED AS EARLY
AS 3000 BCE, THE CITY REALLY
BEGAN TO DEVELOP IN 1457, WITH
THE CONSTRUCTION OF EDO
CASTLE (NAMED AFTER THE
WARRIOR EDO SHIGETSUGU).

IN THE EARLY EIGHTEENTH
CENTURY, EDO ALREADY
HAD MORE THAN A MILLION
INHABITANTS. SO WHEN
HOKUSAI WAS BORN IN 1760 IT
WAS ALREADY A BONA FIDE
METROPOLIS, IN THE MODERN
SENSE OF THE TERM.

IT WASN'T THE CAPITAL OF JAPAN, BUT THE SHOGUN – THE MAN WHO GOVERNED THE COUNTRY – HAD HIS RESIDENCE THERE, SO IT MAY AS WELL HAVE BEEN.

AROUND THE SHOGUN'S PALACE WERE THE DWELLINGS OF THE DAIMYO, THE MAIN FEUDAL LORDS, WHILE THE HOMES OF ORDINARY PEOPLE STOOD A LITTLE FURTHER OFF.

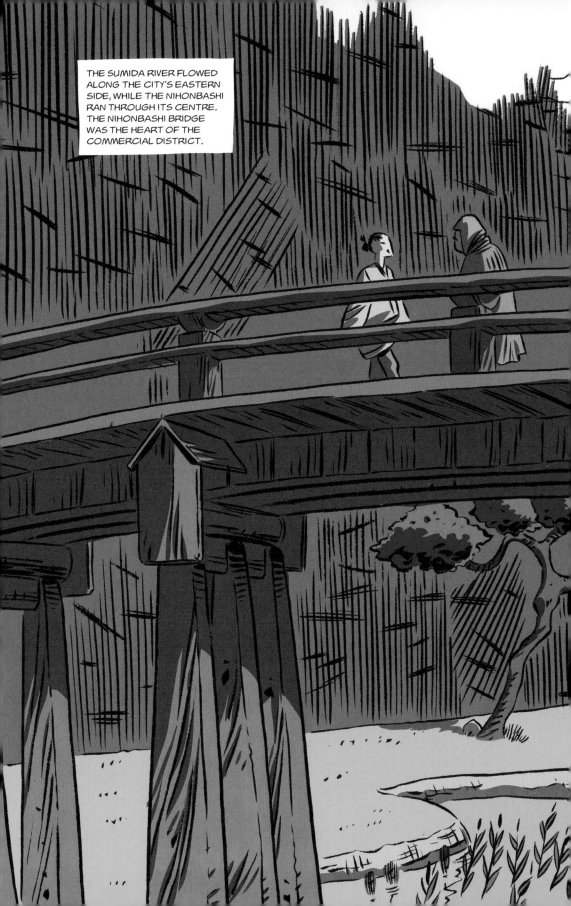

THE SUMIDA RIVER FLOWED ALONG THE CITY'S EASTERN SIDE, WHILE THE NIHONBASHI RAN THROUGH ITS CENTRE. THE NIHONBASHI BRIDGE WAS THE HEART OF THE COMMERCIAL DISTRICT.

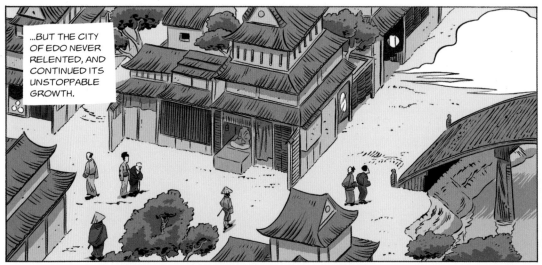

...BUT THE CITY OF EDO NEVER RELENTED, AND CONTINUED ITS UNSTOPPABLE GROWTH.

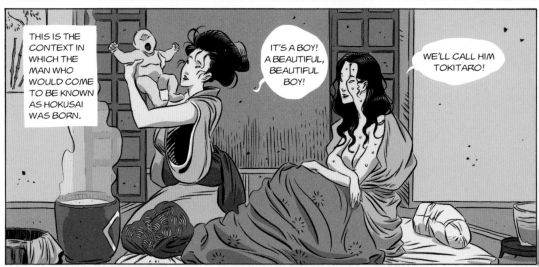

THIS IS THE CONTEXT IN WHICH THE MAN WHO WOULD COME TO BE KNOWN AS HOKUSAI WAS BORN.

IT'S A BOY! A BEAUTIFUL, BEAUTIFUL BOY!

WE'LL CALL HIM TOKITARO!

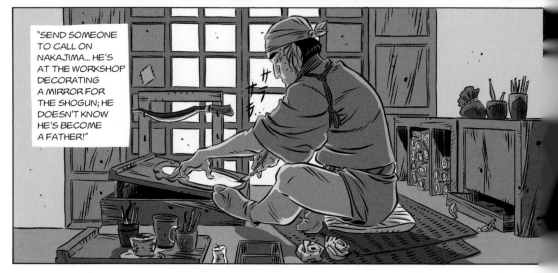

"SEND SOMEONE TO CALL ON NAKAJIMA... HE'S AT THE WORKSHOP DECORATING A MIRROR FOR THE SHOGUN; HE DOESN'T KNOW HE'S BECOME A FATHER!"

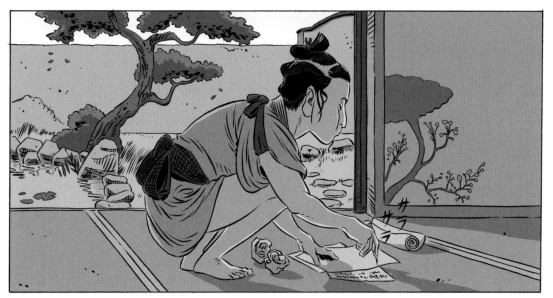

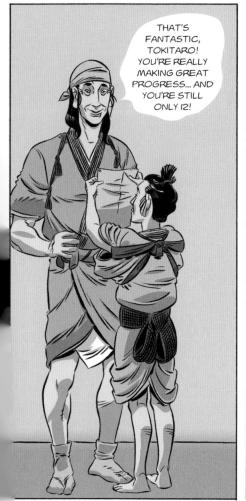

THAT'S FANTASTIC, TOKITARO! YOU'RE REALLY MAKING GREAT PROGRESS... AND YOU'RE STILL ONLY 12!

IF YOU KEEP GOING AT THIS RATE YOU'LL BE BETTER THAN ME SOON... BUT IT'S GETTING LATE...

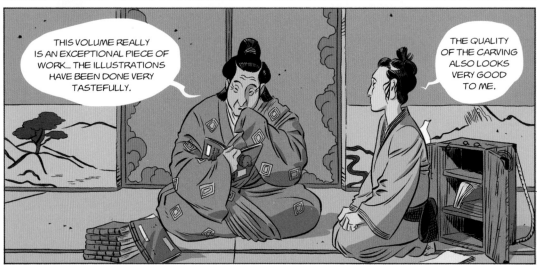

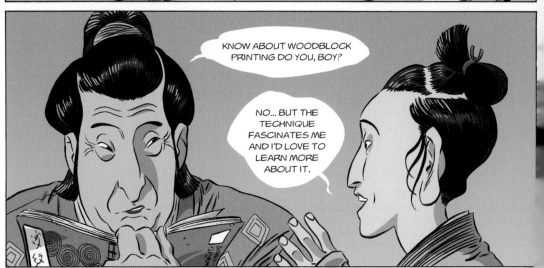

16

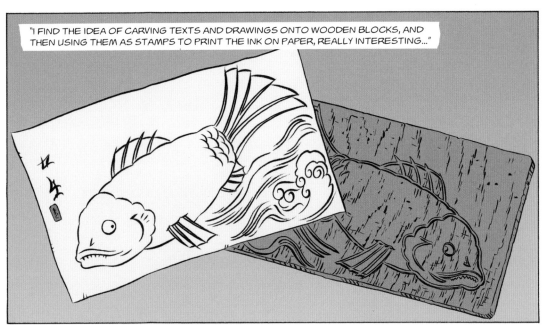

"I FIND THE IDEA OF CARVING TEXTS AND DRAWINGS ONTO WOODEN BLOCKS, AND THEN USING THEM AS STAMPS TO PRINT THE INK ON PAPER, REALLY INTERESTING..."

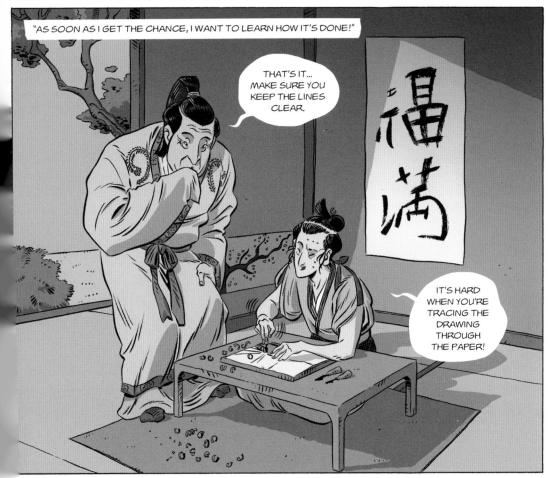

"AS SOON AS I GET THE CHANCE, I WANT TO LEARN HOW IT'S DONE!"

THAT'S IT... MAKE SURE YOU KEEP THE LINES CLEAR.

IT'S HARD WHEN YOU'RE TRACING THE DRAWING THROUGH THE PAPER!

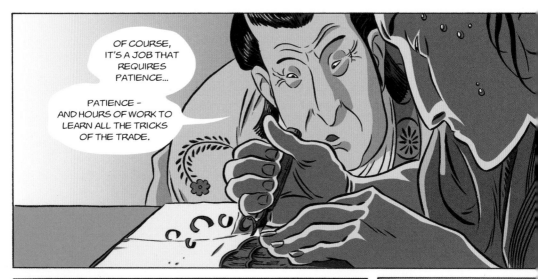

OF COURSE, IT'S A JOB THAT REQUIRES PATIENCE...

PATIENCE – AND HOURS OF WORK TO LEARN ALL THE TRICKS OF THE TRADE.

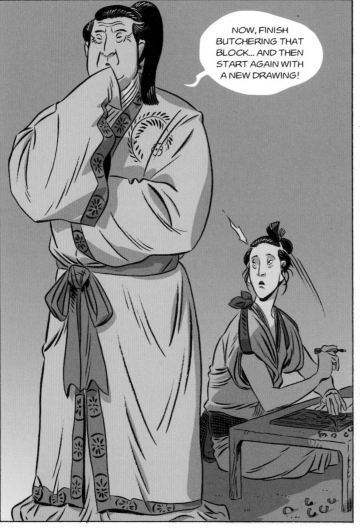

NOW, FINISH BUTCHERING THAT BLOCK... AND THEN START AGAIN WITH A NEW DRAWING!

YOU'LL HAVE TO DO AT LEAST 200 MORE BEFORE YOU CAN SAY YOU'VE LEARNED THE TRADE!

ACCORDING TO THE ANCIENT JAPANESE CALENDAR SYSTEM, IT WAS THE MIDDLE OF THE HŌREKI ERA...

THE TRADITIONAL JAPANESE CALENDAR SCHEME USES THE ERA SYSTEM. THE METHOD ORIGINATED IN THE YEAR 645, WHEN KŌTOKU BECAME THE THIRTY-SIXTH EMPEROR OF JAPAN AND IMPOSED NEW CRITERIA FOR THE SUBDIVISION OF TIME, AS A SYMBOLIC BREAK WITH THE PAST.

ALMOST EVERY CHANGE OF EMPEROR CORRESPONDS TO A CHANGE OF ERA, WHICH MEANS THAT ERAS LAST FOR VARYING LENGTHS OF TIME: SOME LASTED ONLY A FEW MONTHS, WHILE OTHERS WENT ON FOR SEVERAL DECADES. THE SHŌWA ERA, WHICH EQUATES TO THE REIGN OF EMPEROR HIROHITO, WAS THE LONGEST EVER, LASTING FROM 1926 TO 1989.

WITH EVERY CHANGE OF ERA THE NUMBERING OF THE YEARS STARTS AGAIN FROM ONE: THIS IS WHY, WHEN REFERRING TO A PARTICULAR POINT IN JAPANESE HISTORY, YOU HAVE TO SPECIFY BOTH THE ERA AND THE CORRESPONDING YEAR. FOR EXAMPLE, HOKUSAI WAS BORN IN THE TENTH YEAR OF THE HŌREKI ERA – 1760, IN OTHER WORDS.

THE HŌREKI ERA REFERS TO THE REIGN OF THE EMPEROR MOMOZONO AND HIS SISTER, EMPRESS GO-SAKURAMACHI. THE CHANGE OF ERA WAS ESTABLISHED IN 1754 BUT WAS APPLIED RETROSPECTIVELY. THE HŌREKI ERA THEREFORE OFFICIALLY BEGAN IN 1751 AND ENDED THIRTEEN YEARS LATER, IN 1764.

UNDERSTANDING HOW JAPANESE HISTORY IS DIVIDED UP CAN BE COMPLICATED IF YOU'RE NOT FAMILIAR WITH IT. BUT ULTIMATELY IT ISN'T ALL THAT DIFFICULT: THE FIRST SUBDIVISION IS BY AGES (PREHISTORIC, CLASSICAL AND SO ON), WHICH ARE THEN BROKEN DOWN INTO PERIODS, WHICH ARE IN TURN MADE UP OF DIFFERENT ERAS. FOR EXAMPLE, THE HŌREKI ERA (1751-64) SITS WITHIN THE EDO PERIOD (1603-1868), WHICH IN TURN IS PART OF THE PRE-MODERN AGE (1573-1868).

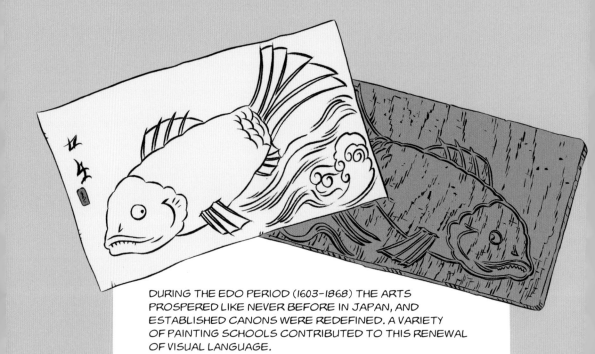

DURING THE EDO PERIOD (1603–1868) THE ARTS
PROSPERED LIKE NEVER BEFORE IN JAPAN, AND
ESTABLISHED CANONS WERE REDEFINED. A VARIETY
OF PAINTING SCHOOLS CONTRIBUTED TO THIS RENEWAL
OF VISUAL LANGUAGE.

THE **KANO SCHOOL**, FOR EXAMPLE, SURVIVED FOR
ABOUT THREE CENTURIES. SPECIALIZING IN LANDSCAPE
PAINTING, IT WORKED MAINLY FOR THE NOBLE AND MILITARY
CLASSES, PRODUCING EXTREMELY REFINED IMAGES.

INSPIRED BY ANCIENT JAPANESE ART, THE WORK OF THE
TOSA SCHOOL WAS CHARACTERIZED BY A SIMPLICITY OF
LINE AND ESSENTIAL FORMS, WITH SUBJECTS DRAWN
FROM JAPANESE TRADITION AND HISTORY.

THE **RINPA SCHOOL** REWORKED ELEMENTS OF THE STYLE
KNOWN AS *YAMATO-E*, FOCUSING ON THE DEPICTION OF
SIMPLE NATURAL ELEMENTS (FLOWERS, BIRDS) ON GOLD
BACKGROUNDS.

WHILE THESE WERE THE MOST SIGNIFICANT, MANY
PAINTING SCHOOLS OF THE PERIOD CONTRIBUTED
TO A CHANGE IN THE CONCEPTION OF ART, AND THEIR
INFLUENCE IS STILL FELT TODAY.

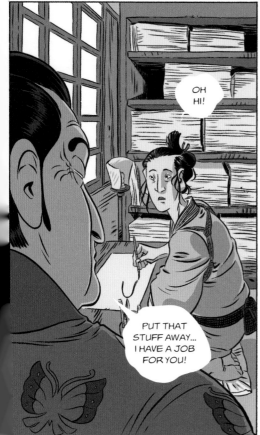

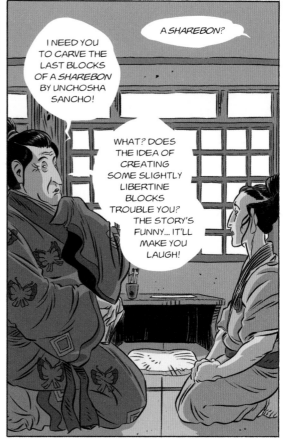

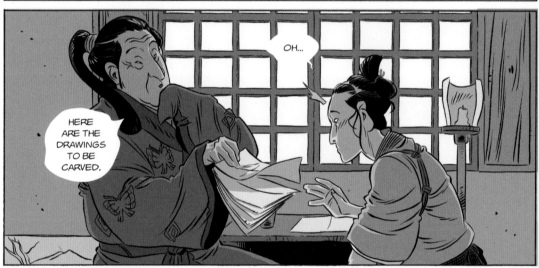

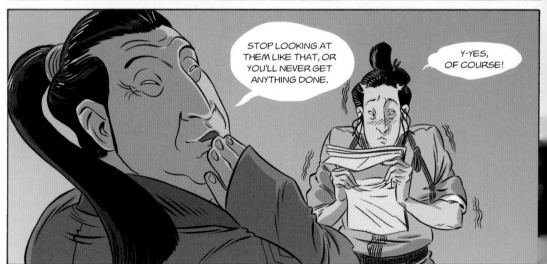

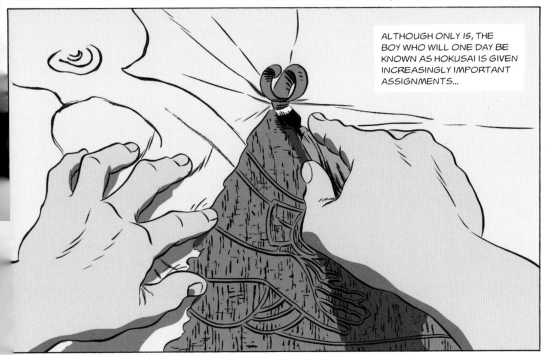

ALTHOUGH ONLY 15, THE BOY WHO WILL ONE DAY BE KNOWN AS HOKUSAI IS GIVEN INCREASINGLY IMPORTANT ASSIGNMENTS...

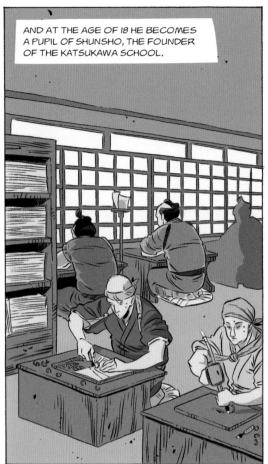

AND AT THE AGE OF 18 HE BECOMES A PUPIL OF SHUNSHO, THE FOUNDER OF THE KATSUKAWA SCHOOL.

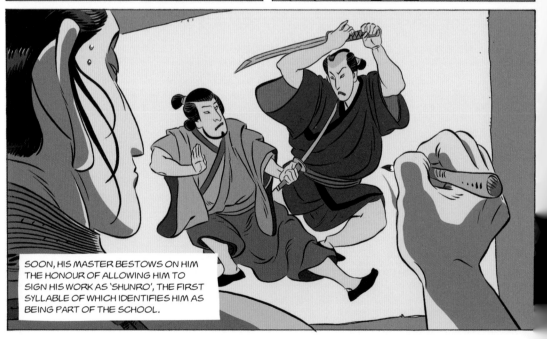

SOON, HIS MASTER BESTOWS ON HIM THE HONOUR OF ALLOWING HIM TO SIGN HIS WORK AS 'SHUNRO', THE FIRST SYLLABLE OF WHICH IDENTIFIES HIM AS BEING PART OF THE SCHOOL.

AT THAT TIME, EDO WAS A SOCIAL AND ARTISTIC
REFERENCE POINT FOR THE WHOLE COUNTRY.
THE CITY'S NOBILITY LOVED SPENDING TIME AT TEA
HOUSES, PERFORMANCES OF KABUKI THEATRE AND
SUMO MATCHES.

ACTORS, SUMO WRESTLERS AND GEISHAS THUS BECAME
FREQUENT SUBJECTS FOR ILLUSTRATIONS AND PAINTINGS,
IN ADDITION TO THE USUAL LANDSCAPES.

IN THIS CLIMATE, A TYPE OF
ARTISTIC PRINTMAKING KNOWN
AS **UKIYO-E** (IMAGES OF THE
FLOATING WORLD) BECOMES
INCREASINGLY SUCCESSFUL.

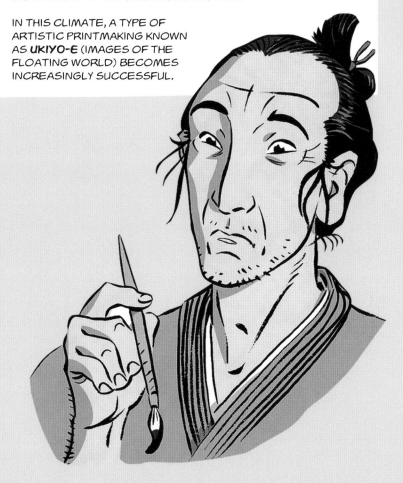

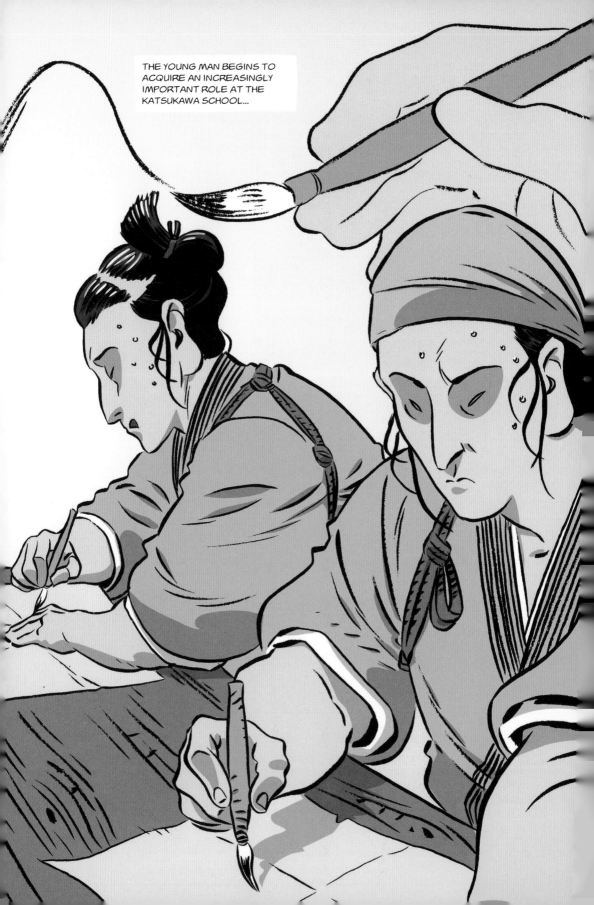

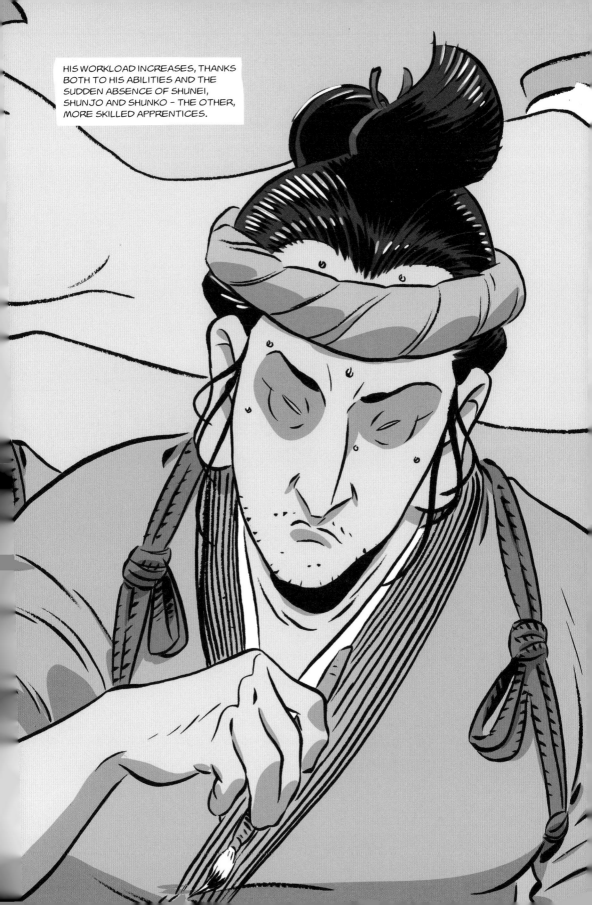

HIS WORKLOAD INCREASES, THANKS BOTH TO HIS ABILITIES AND THE SUDDEN ABSENCE OF SHUNEI, SHUNJO AND SHUNKO – THE OTHER, MORE SKILLED APPRENTICES.

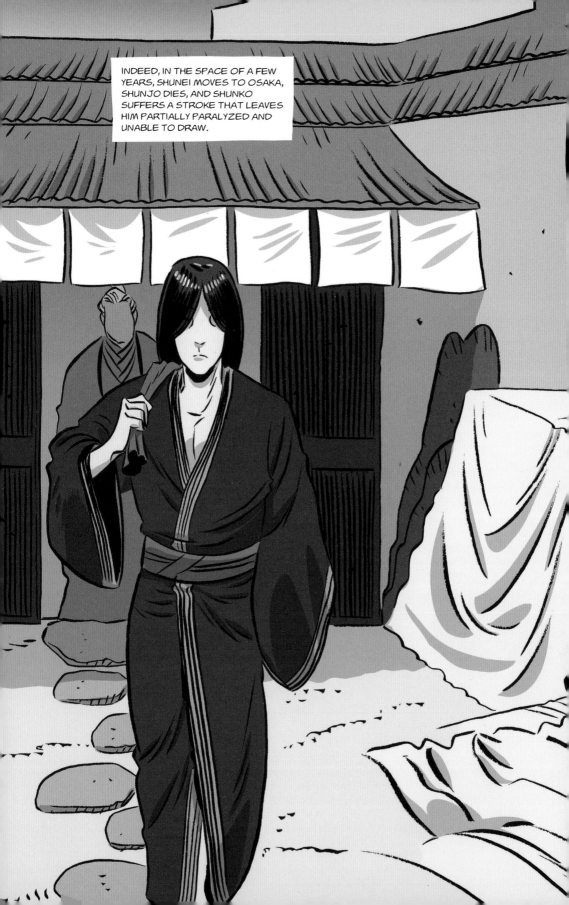

INDEED, IN THE SPACE OF A FEW YEARS, SHUNEI MOVES TO OSAKA, SHUNJO DIES, AND SHUNKO SUFFERS A STROKE THAT LEAVES HIM PARTIALLY PARALYZED AND UNABLE TO DRAW.

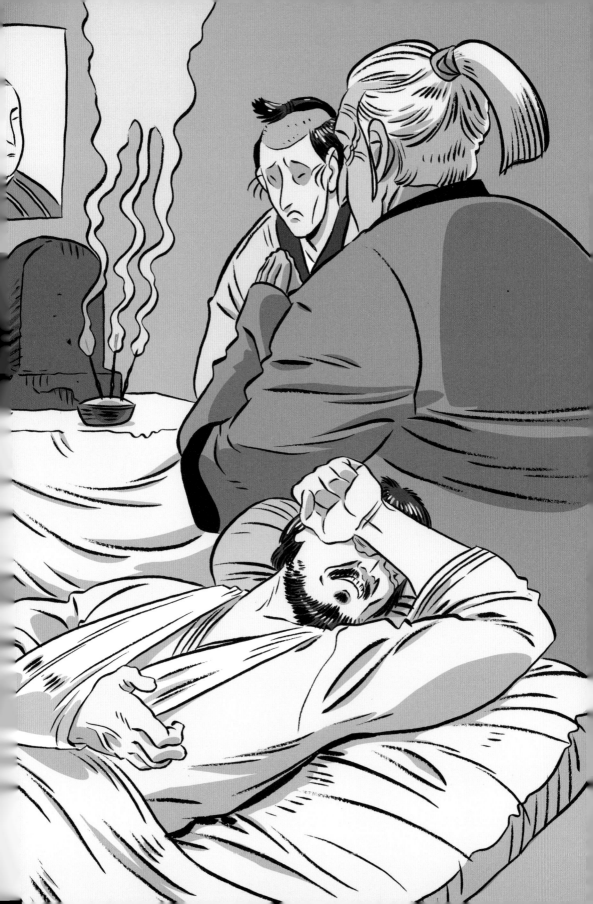

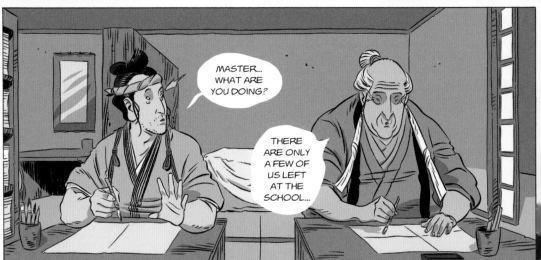

MASTER... WHAT ARE YOU DOING?

THERE ARE ONLY A FEW OF US LEFT AT THE SCHOOL...

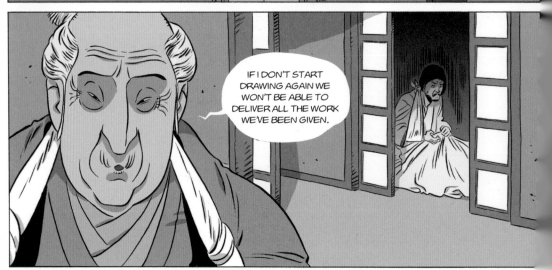

IF I DON'T START DRAWING AGAIN WE WON'T BE ABLE TO DELIVER ALL THE WORK WE'VE BEEN GIVEN.

THE MOST COMMONLY PORTRAYED FEMALE FIGURES IN ARTWORKS OF THE TIME ARE GEISHAS AND COURTESANS, DEPICTED WITH CHARACTERISTICS THAT REFLECT THE AESTHETIC CONVENTIONS OF THE PERIOD.

THE MOST VISIBLE COMMON TRAIT OF THIS TYPE OF DRAWING IS THE COLOUR OF THE WOMEN'S SKIN: ALWAYS EXTREMELY PALE, IT WORKS LIKE A MASK, CONCEALING MORE THAN IT SHOWS, AND CREATING A SENSE OF THE MYSTERIOUS AND ENIGMATIC. ALONG WITH THEIR FLEETING GLANCES, THIS ENDOWS THE FIGURES WITH A CHARM THAT IS AT ONCE MYSTERIOUS, SEDUCTIVE AND ELUSIVE.

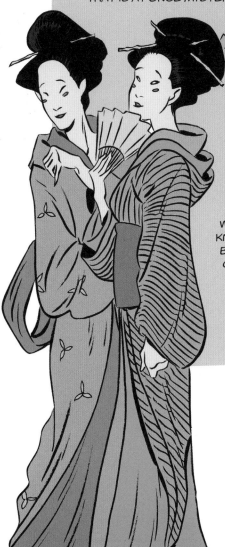

WHETHER SEEN IN CLOSE-UP OR IN FULL-LENGTH PORTRAITS, THEY ARE ENIGMATIC CHARACTERS: IMPOSSIBLE TO UNDERSTAND AND THUS EXTREMELY BEGUILING.

THE GEISHA IS A TYPICALLY JAPANESE FIGURE. SHE IS AN ARTIST WHOSE TASK IS TO ENTERTAIN THE NOBLE CLASSES WITH HER SKILLS AS A SINGER, DANCER AND MUSICIAN. ORIGINALLY THE JOB WAS PERFORMED BY A MAN, KNOWN AS THE *TAIKOMOCHI*, BUT FROM THE MID-EIGHTEENTH CENTURY WOMEN BEGAN TO DO IT AS WELL – AND IN A SHORT TIME THERE WAS SUCH HIGH DEMAND FOR THEM THAT THEY SUPERSEDED THEIR MALE COUNTERPARTS.

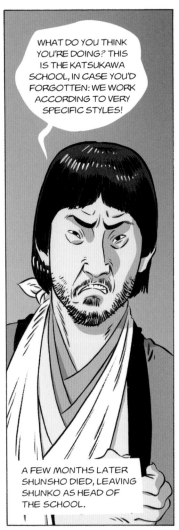

WHAT DO YOU THINK YOU'RE DOING? THIS IS THE KATSUKAWA SCHOOL, IN CASE YOU'D FORGOTTEN: WE WORK ACCORDING TO VERY SPECIFIC STYLES!

A FEW MONTHS LATER SHUNSHO DIED, LEAVING SHUNKO AS HEAD OF THE SCHOOL.

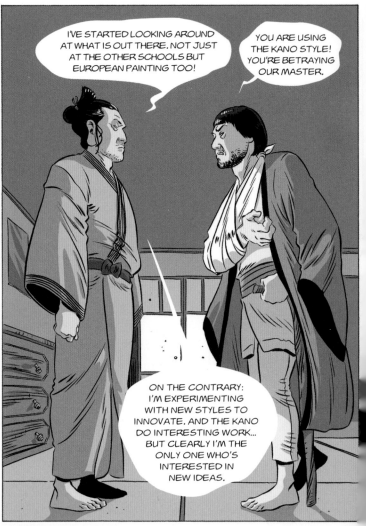

I'VE STARTED LOOKING AROUND AT WHAT IS OUT THERE. NOT JUST AT THE OTHER SCHOOLS BUT EUROPEAN PAINTING TOO!

YOU ARE USING THE KANO STYLE! YOU'RE BETRAYING OUR MASTER.

ON THE CONTRARY: I'M EXPERIMENTING WITH NEW STYLES TO INNOVATE. AND THE KANO DO INTERESTING WORK... BUT CLEARLY I'M THE ONLY ONE WHO'S INTERESTED IN NEW IDEAS.

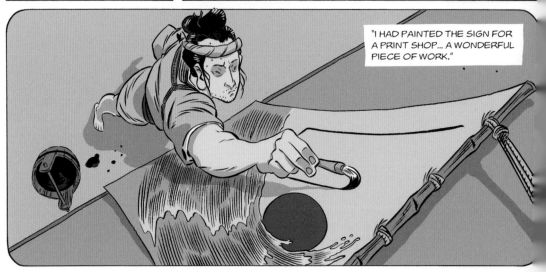

"I HAD PAINTED THE SIGN FOR A PRINT SHOP... A WONDERFUL PIECE OF WORK."

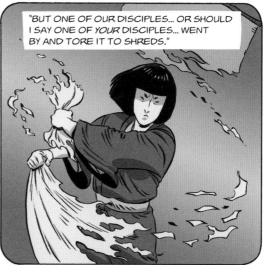

"BUT ONE OF OUR DISCIPLES... OR SHOULD I SAY ONE OF *YOUR* DISCIPLES... WENT BY AND TORE IT TO SHREDS."

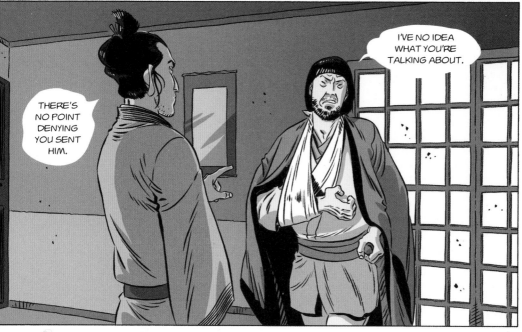

I'VE NO IDEA WHAT YOU'RE TALKING ABOUT.

THERE'S NO POINT DENYING YOU SENT HIM.

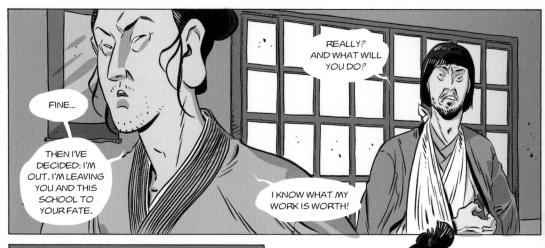

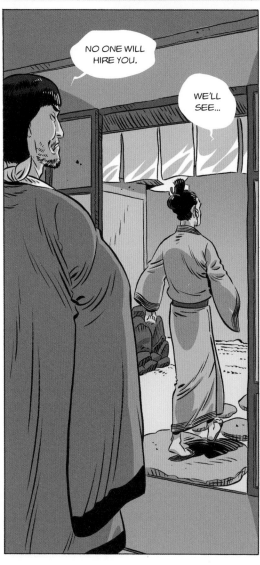

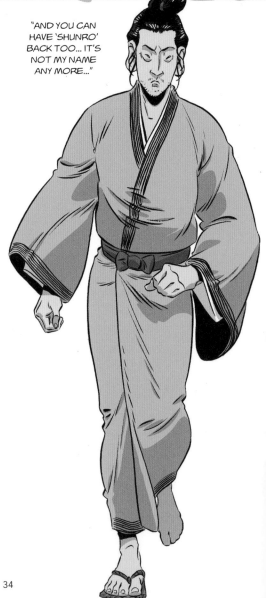

34

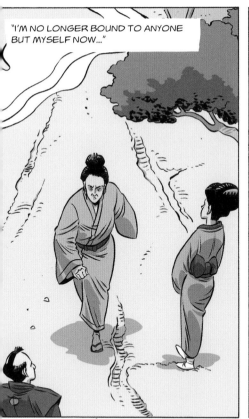

"I'M NO LONGER BOUND TO ANYONE BUT MYSELF NOW..."

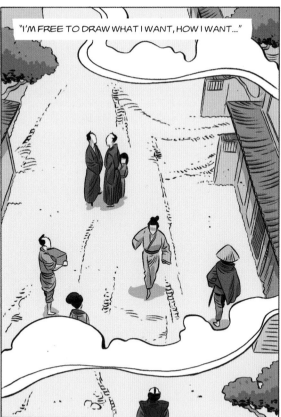

"I'M FREE TO DRAW WHAT I WANT, HOW I WANT..."

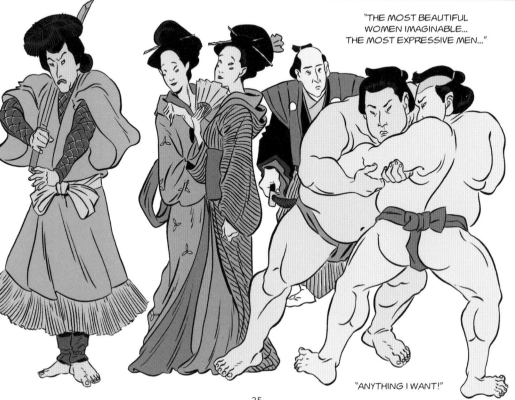

"THE MOST BEAUTIFUL WOMEN IMAGINABLE... THE MOST EXPRESSIVE MEN..."

"ANYTHING I WANT!"

THE EDO PERIOD WAS ONE OF THE MOST INTERESTING
ERAS IN TERMS OF THE ARTISTIC REPRESENTATION
OF THE HUMAN BODY – AND NOT ONLY IN RELATION
TO FEMALE BEAUTY.

LOTS OF PRINTS FEATURE ACTORS PERFORMING KABUKI
THEATRE, A TYPICALLY JAPANESE FORM WHICH DIFFERS
SIGNIFICANTLY FROM THE WESTERN TRADITION. KABUKI
PERFORMANCES ARE FRAGMENTED, COMPOSED OF
A SERIES OF DIFFERENT SEQUENCES INDEPENDENT
OF ONE ANOTHER, AND IN WHICH GREAT IMPORTANCE
IS PLACED ON HOW THE PIECE IS CHOREOGRAPHED.

SUMO WRESTLERS, WITH THEIR ENORMOUS STRENGTH,
ARE ALSO OFTEN AT THE CENTRE OF THIS TYPE OF
ILLUSTRATION. THEIR POWERFUL AND DYNAMIC BODIES
– CONSTANTLY IN MOTION AND ENGAGED IN BATTLES OF
STRENGTH – ARE THE BEST WAY OF EXPRESSING THE
SPECTACLE OF JAPAN'S MOST TYPICAL MARTIAL ART.

SUMO IS THE NATIONAL SPORT OF JAPAN. IT'S A FORM OF
WRESTLING, THE AIM OF WHICH IS TO PUSH THE OPPONENT
OUT OF THE RING, OR FORCE HIM TO THE GROUND.

IT WAS INVENTED ABOUT 1500 YEARS AGO, WHEN IT HAD
A STRONG RITUAL ELEMENT AND WAS PRACTISED
EXCLUSIVELY BY MEN. HOWEVER, IN RECENT DECADES
A PURELY ATHLETIC VERSION OF THE SPORT HAS BEEN
DEVELOPED, ONE STRIPPED OF ITS RITUAL ASPECT,
WHICH IS ALSO OPEN TO WOMEN.

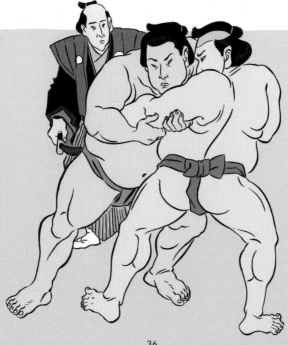

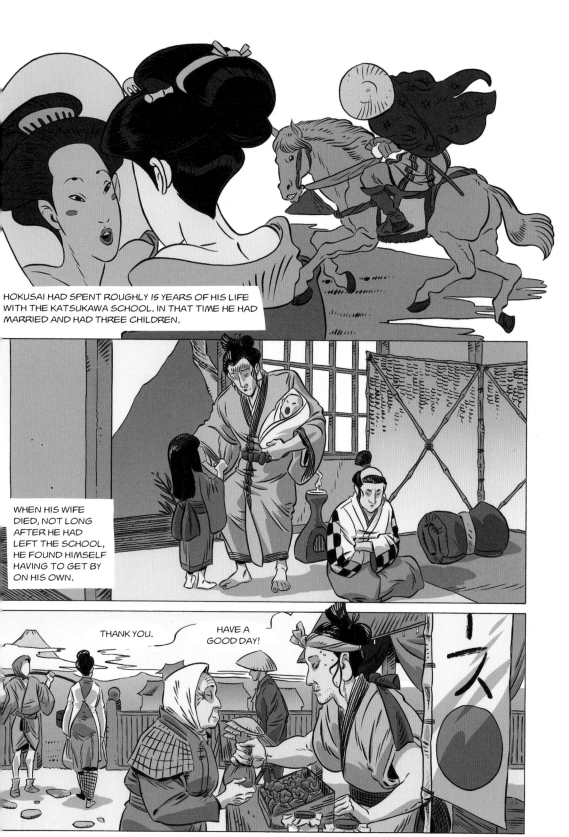

HOKUSAI HAD SPENT ROUGHLY 15 YEARS OF HIS LIFE WITH THE KATSUKAWA SCHOOL. IN THAT TIME HE HAD MARRIED AND HAD THREE CHILDREN.

WHEN HIS WIFE DIED, NOT LONG AFTER HE HAD LEFT THE SCHOOL, HE FOUND HIMSELF HAVING TO GET BY ON HIS OWN.

THANK YOU.

HAVE A GOOD DAY!

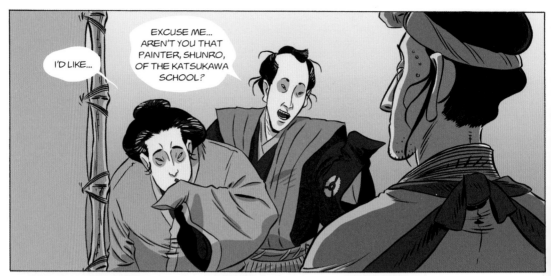

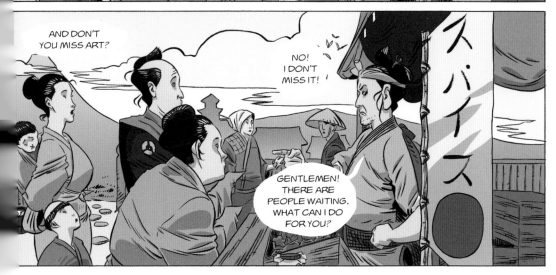

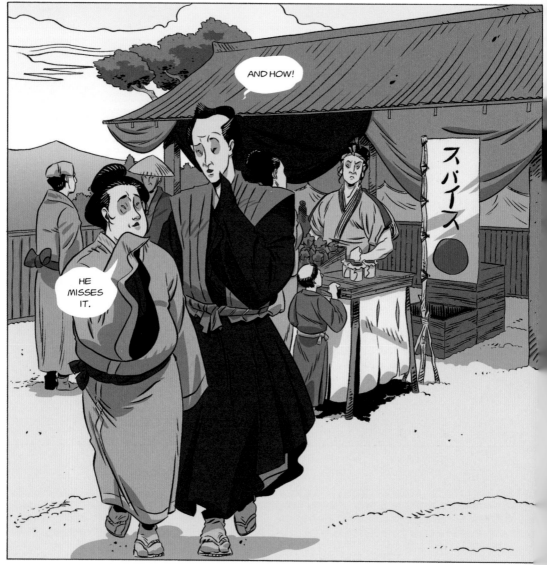

IN THE YEARS HOKUSAI WAS ACTIVE, FROM THE END OF THE EIGHTEENTH TO THE START OF THE NINETEENTH CENTURY, JAPANESE ART UNDERWENT A PERIOD OF INCREDIBLE SPLENDOUR. A GREAT NUMBER OF OTHER PAINTERS WERE WORKING AT THE SAME TIME, AND THIS WIDE RANGE OF ARTISTS AND IDEAS CONTRIBUTED TO A SHIFT IN THE NATIONAL IMAGINATION, INCLUDING BEYOND *UKIYO-E*.

INSPIRED BY WESTERN ART, **SHIBA KŌKAN** (1747–1818) WAS THE FIRST JAPANESE ARTIST TO MAKE USE OF GEOMETRIC PERSPECTIVE. KŌKAN WAS A MASTER OF *UKIYO-E* AND OIL PAINTING, AND PARTICULARLY ADEPT AT IMITATING THE STYLES OF OTHERS, TO THE EXTENT THAT HE PAINTED SEVERAL FORGERIES OF HIS CONTEMPORARY SUZUKI HARUNOBU.

MATSUMURA GOSHUN (1752–1811) DIDN'T BEGIN HIS ARTISTIC CAREER UNTIL THE AGE OF 25, BUT NONETHELESS BECAME A TRUE MASTER. HIS APPRECIATION OF EUROPEAN NATURALISM LED HIM TO CHANGE THE TRADITIONAL JAPANESE STYLE AND HE FOUNDED THE SHIJO SCHOOL WITH HIS FORMER MASTER MARUYAMA ŌKYO.

KITAGAWA UTAMARO (c.1753–1806) IS ONE OF THE MOST EMBLEMATIC ARTISTS OF THE PERIOD, ALONG WITH HOKUSAI AND HIROSHIGE (BELOW). A PUPIL OF THE KANO SCHOOL, HE SOON BECAME ONE OF THE MAJOR EXPONENTS OF *UKIYO-E*. HIS FEMALE PORTRAITS ARE PARTICULARLY WELL KNOWN AND CONTRIBUTED TO HIS POPULARITY IN THE MID-NINETEENTH CENTURY, INCLUDING IN EUROPE.

THE WORK FOR WHICH **UTAGAWA HIROSHIGE** (1797–1858) IS BEST KNOWN IS HIS SERIES, *ONE HUNDRED FAMOUS VIEWS OF EDO*, WHICH HE PAINTED A FEW MONTHS BEFORE HIS DEATH. HIROSHIGE CREATED ROUGHLY 400 WOODBLOCKS OVER THE COURSE OF HIS CAREER, WHICH ALSO HAD AN INFLUENCE ON EUROPEAN PAINTING.

THE THREE ECCENTRICS: ITŌ JAKUCHŪ (1716–1800), **SOGA SHŌHAKU** (1730–81) AND **NAGASAWA ROSETSU** (1754–99) ARE KNOWN FOR THEIR EXTRAVAGANCE. THEIR SHARED CHARACTERISTIC IS THAT OF HAVING MADE WORK THAT SITS OUTSIDE ESTABLISHED CONVENTION, BY EMPLOYING UNUSUAL AND GARISH COLOURS, ECCENTRIC COMPOSITIONAL STYLES AND ORIGINAL PAINTING TECHNIQUES.

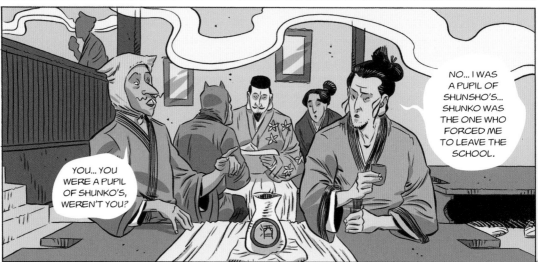

NO... I WAS A PUPIL OF SHUNSHO'S... SHUNKO WAS THE ONE WHO FORCED ME TO LEAVE THE SCHOOL.

YOU... YOU WERE A PUPIL OF SHUNKO'S, WEREN'T YOU?

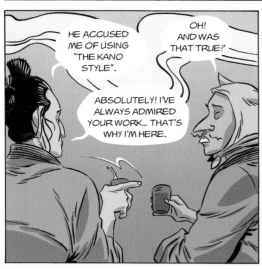

HE ACCUSED ME OF USING "THE KANO STYLE".

OH! AND WAS THAT TRUE?

ABSOLUTELY! I'VE ALWAYS ADMIRED YOUR WORK... THAT'S WHY I'M HERE.

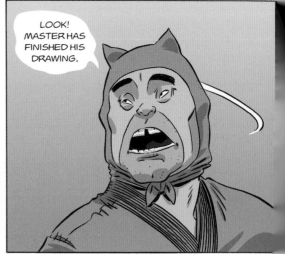

LOOK! MASTER HAS FINISHED HIS DRAWING.

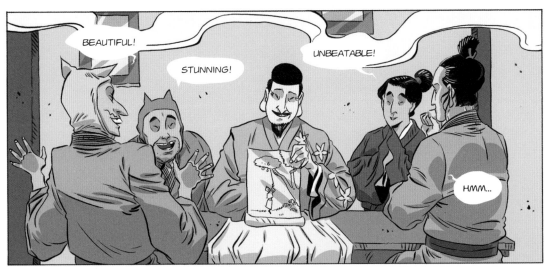

BEAUTIFUL!

STUNNING!

UNBEATABLE!

HMM...

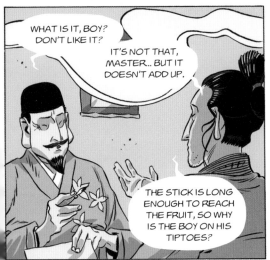

WHAT IS IT, BOY? DON'T LIKE IT?

IT'S NOT THAT, MASTER... BUT IT DOESN'T ADD UP.

THE STICK IS LONG ENOUGH TO REACH THE FRUIT, SO WHY IS THE BOY ON HIS TIPTOES?

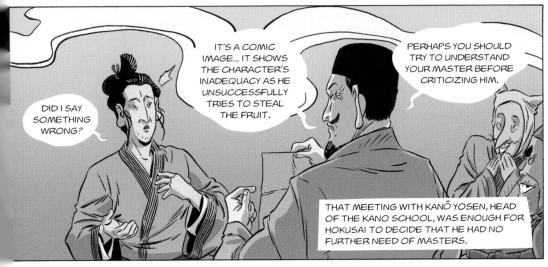

IT'S A COMIC IMAGE... IT SHOWS THE CHARACTER'S INADEQUACY AS HE UNSUCCESSFULLY TRIES TO STEAL THE FRUIT.

PERHAPS YOU SHOULD TRY TO UNDERSTAND YOUR MASTER BEFORE CRITICIZING HIM.

DID I SAY SOMETHING WRONG?

THAT MEETING WITH KANŌ YOSEN, HEAD OF THE KANO SCHOOL, WAS ENOUGH FOR HOKUSAI TO DECIDE THAT HE HAD NO FURTHER NEED OF MASTERS.

43

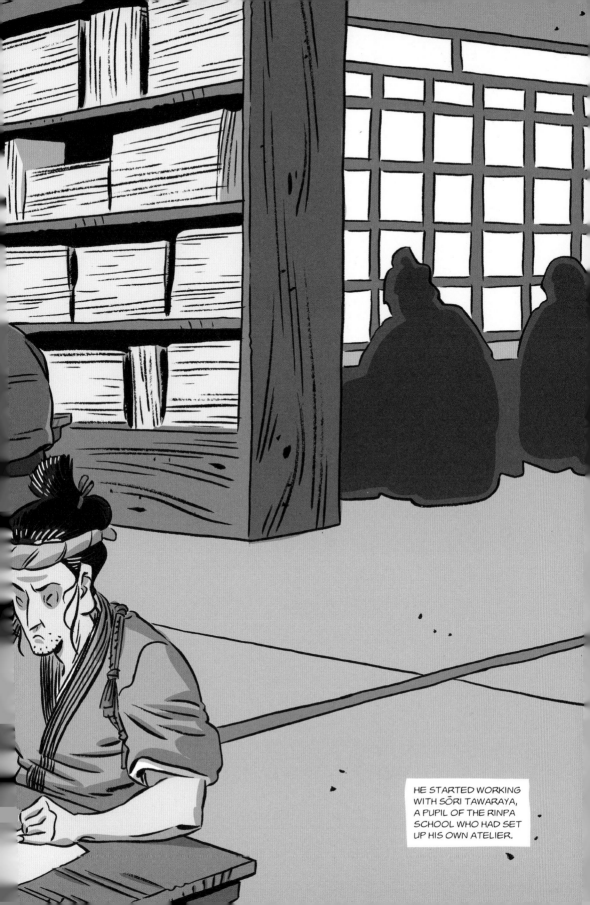

HE STARTED WORKING
WITH SŌRI TAWARAYA,
A PUPIL OF THE RINPA
SCHOOL WHO HAD SET
UP HIS OWN ATELIER.

THE TIME SPENT WORKING FOR
TAWARAYA COINCIDED WITH A
NOTABLE EVOLUTION IN HOKUSAI'S
DRAWING, WHICH MOVED EVER
CLOSER TO HIS MATURE STYLE.

THE TERM **UKIYO-E** MEANS "IMAGES OF THE FLOATING WORLD" AND IS USED TO REFER TO A STYLE OF ARTISTIC PRINT TYPICAL OF THE EDO PERIOD. THE MAIN SUBJECTS OF UKIYO-E WERE TAKEN FROM DAILY LIFE, AND PARTICULARLY FROM ACTIVITIES RELATING TO ENTERTAINMENT AND PLEASURE.

AS A PICTORIAL STYLE IT WAS CLOSELY BOUND UP WITH ITS PRODUCTION TECHNIQUE, IN WHICH A WOODEN BLOCK WAS CARVED AND, MUCH LIKE IN TRADITIONAL WOODCUTS, USED AS A STAMP FOR PRINTING ON PAPER.

IT WAS THEREFORE POSSIBLE TO MAKE MULTIPLE COPIES OF THE IMAGE AT A LOW COST, IN A SHORT SPACE OF TIME, A FEATURE WHICH LED TO THE POPULARIZATION OF THIS TYPE OF PRINT AMONG ORDINARY PEOPLE. THE ARISTOCRACY – WHICH WAS TRADITIONALLY MORE INCLINED TO PURCHASING WORKS OF ART – PREFERRED TO HANG UNIQUE PIECES IN THEIR HOMES, FAVOURING ORIGINAL PAINTINGS OVER PRINTS MADE IN SERIES.

AS A SYSTEM OF MASS PRODUCTION, THE *UKIYO-E* REQUIRED A VARIETY OF DIFFERENT PROFESSIONS. FIRST OF ALL THERE WERE THE ARTISTS, OBVIOUSLY, WHO DESIGNED THE IMAGES; THEN THE CARVERS, WHO REPRODUCED THE DESIGN ON THE WOODBLOCK; THEN CAME THE PRINTERS, WHO APPLIED INK TO THE BLOCK AND PRESSED THE IMAGE ONTO PAPER; AND, FINALLY, NONE OF THIS WOULD HAVE BEEN POSSIBLE WITHOUT A PUBLISHER WHO WAS ABLE TO FINANCE THE WORK AND SELL THE FINISHED PRODUCT.

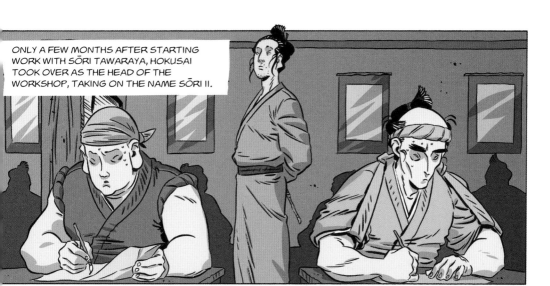

ONLY A FEW MONTHS AFTER STARTING WORK WITH SŌRI TAWARAYA, HOKUSAI TOOK OVER AS THE HEAD OF THE WORKSHOP, TAKING ON THE NAME SŌRI II.

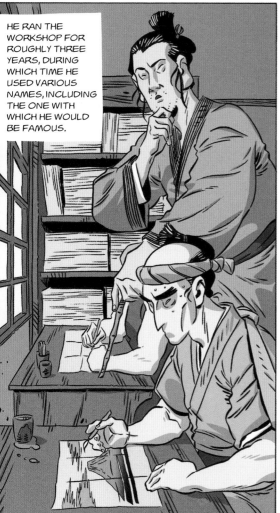

HE RAN THE WORKSHOP FOR ROUGHLY THREE YEARS, DURING WHICH TIME HE USED VARIOUS NAMES, INCLUDING THE ONE WITH WHICH HE WOULD BE FAMOUS.

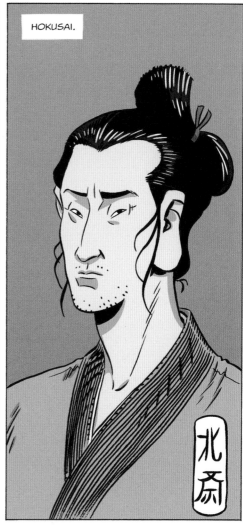

HOKUSAI.

19

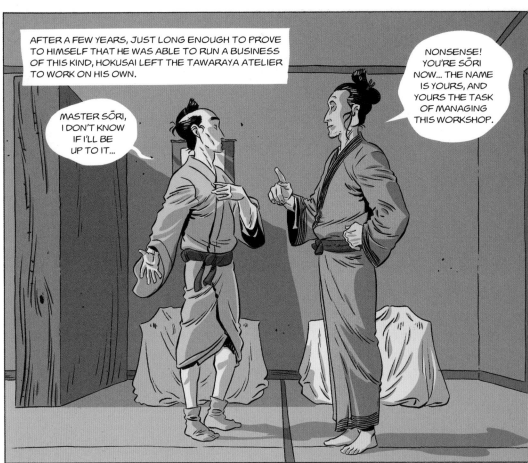

AFTER A FEW YEARS, JUST LONG ENOUGH TO PROVE TO HIMSELF THAT HE WAS ABLE TO RUN A BUSINESS OF THIS KIND, HOKUSAI LEFT THE TAWARAYA ATELIER TO WORK ON HIS OWN.

MASTER SŌRI, I DON'T KNOW IF I'LL BE UP TO IT...

NONSENSE! YOU'RE SŌRI NOW... THE NAME IS YOURS, AND YOURS THE TASK OF MANAGING THIS WORKSHOP.

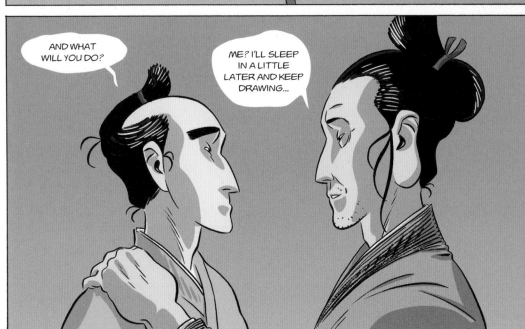

AND WHAT WILL YOU DO?

ME? I'LL SLEEP IN A LITTLE LATER AND KEEP DRAWING...

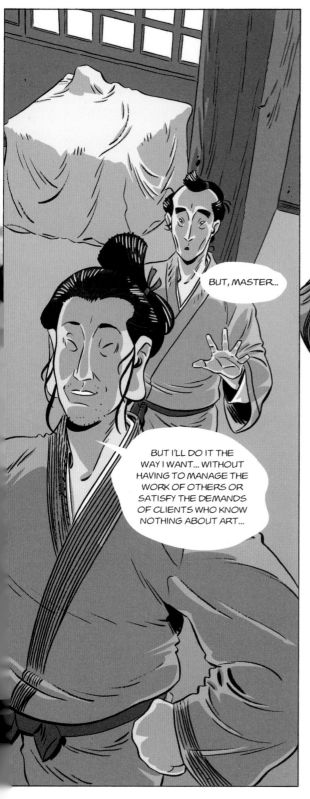

BUT, MASTER...

BUT I'LL DO IT THE WAY I WANT... WITHOUT HAVING TO MANAGE THE WORK OF OTHERS OR SATISFY THE DEMANDS OF CLIENTS WHO KNOW NOTHING ABOUT ART...

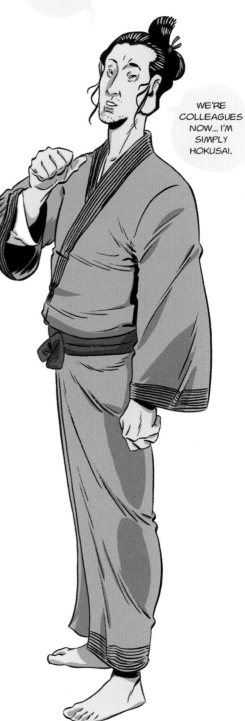

MASTER IS NO LONGER MY TITLE; DON'T CALL ME THAT.

WE'RE COLLEAGUES NOW... I'M SIMPLY HOKUSAI.

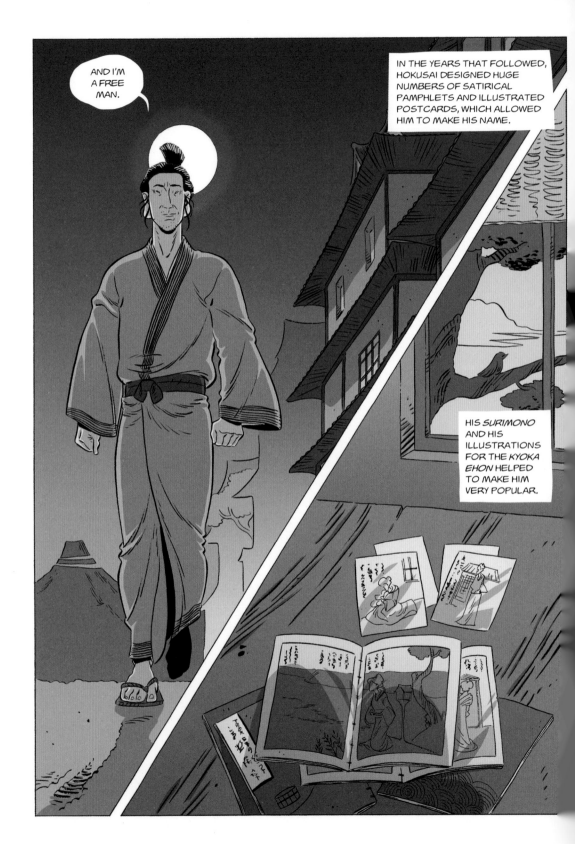

AND I'M A FREE MAN.

IN THE YEARS THAT FOLLOWED, HOKUSAI DESIGNED HUGE NUMBERS OF SATIRICAL PAMPHLETS AND ILLUSTRATED POSTCARDS, WHICH ALLOWED HIM TO MAKE HIS NAME.

HIS *SURIMONO* AND HIS ILLUSTRATIONS FOR THE *KYOKA EHON* HELPED TO MAKE HIM VERY POPULAR.

SURIMONO ARE SMALL CELEBRATORY PRINTS THAT WERE AT THE HEIGHT OF THEIR POPULARITY BETWEEN THE END OF THE EIGHTEENTH AND THE EARLY NINETEENTH CENTURY. THEY WERE POSTCARDS MADE USING WOODBLOCK TECHNIQUES, MADE TO ORDER FOR THE MOST DIVERSE REASONS: ARTISANS WOULD COMMISSION THEM AS GIFTS FOR THEIR CUSTOMERS, FOR EXAMPLE, OR KABUKI ACTORS WOULD CELEBRATE KEY MOMENTS OF THEIR CAREERS WITH THEM. THEY WOULD INCLUDE AN ILLUSTRATION AND OFTEN A FEW LINES OF TEXT RELATING TO THE OCCASION FOR WHICH THEY HAD BEEN MADE.

THEIR SMALL SIZE (THE LONG SIDE OF THE PAGE MEASURED ABOUT 20CM/8IN) MADE THE CARVING VERY DEMANDING – PARTICULARLY IN TERMS OF THE CALLIGRAPHIC ELEMENTS – WHICH IS WHY TRULY EXCEPTIONAL ARTISTS WERE NEEDED TO MAKE THEM.

THE **KYOKA EHON** WERE ILLUSTRATED SATIRICAL PAMPHLETS CONSISTING MAINLY OF COLLECTIONS OF FUNNY POEMS ACCOMPANIED BY IMAGES. AT THE TURN OF THE NINETEENTH CENTURY THESE PAMPHLETS ENJOYED ENORMOUS POPULARITY AND LOTS OF ARTISTS WERE INVOLVED IN THEIR PRODUCTION.

SOMETIMES IT HAPPENED THAT, AFTER DRAWING FOR OTHER AUTHORS, AN ILLUSTRATOR MIGHT DECIDE TO WRITE THE PAMPHLET TEXTS THEMSELVES, THUS BECOMING THE SOLE AUTHOR. SOME RESEARCHERS HAVE SUGGESTED THAT HOKUSAI CREATED OVER 40 *KYOKA EHON*.

THE ART OF **SHODO**, OR JAPANESE CALLIGRAPHY, IS AN ANCIENT ARTFORM THAT REQUIRES IMMENSE PRECISION AND EXTENSIVE PRACTICE TO MASTER. ALTHOUGH OF CHINESE ORIGIN, *SHODO* BECAME QUINTESSENTIALLY JAPANESE AROUND 1800, WHEN THE HIRAGANA AND KATAKANA ALPHABETS WERE INTRODUCED IN JAPAN AND CALLIGRAPHIC ART TOOK A NEW DIRECTION.

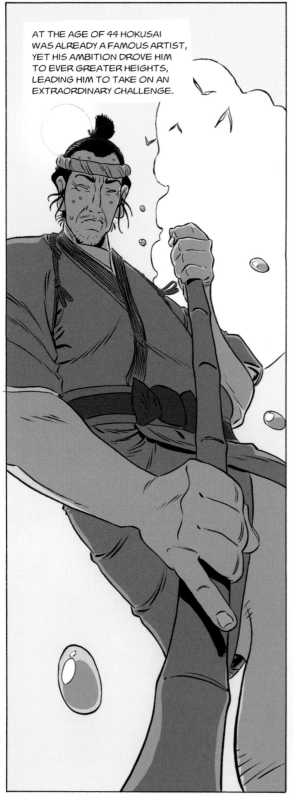

AT THE AGE OF 44 HOKUSAI WAS ALREADY A FAMOUS ARTIST, YET HIS AMBITION DROVE HIM TO EVER GREATER HEIGHTS, LEADING HIM TO TAKE ON AN EXTRAORDINARY CHALLENGE.

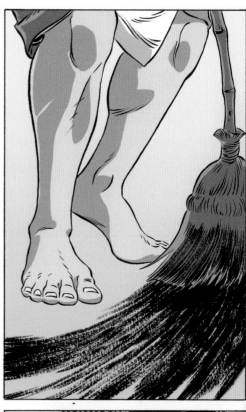

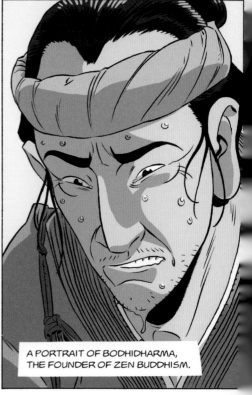

A PORTRAIT OF BODHIDHARMA, THE FOUNDER OF ZEN BUDDHISM.

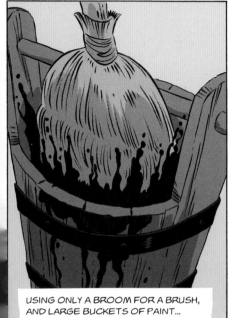

USING ONLY A BROOM FOR A BRUSH, AND LARGE BUCKETS OF PAINT...

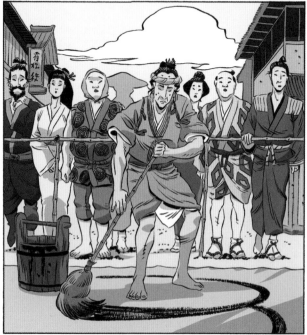

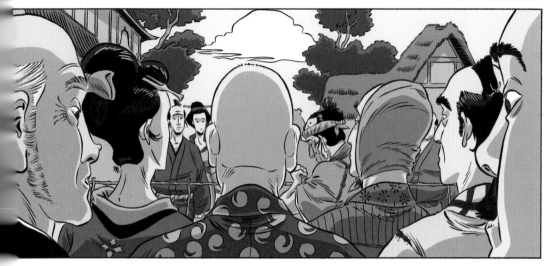

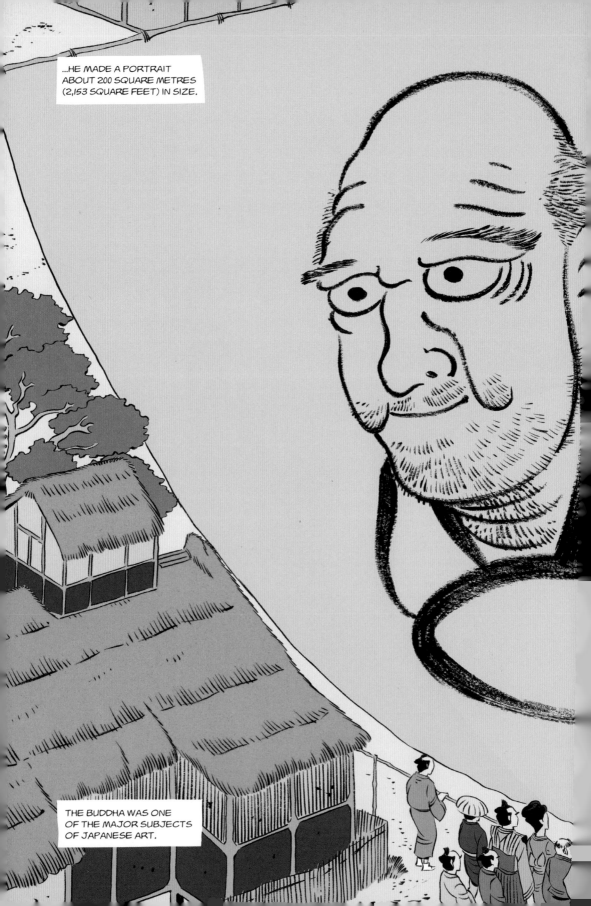

...HE MADE A PORTRAIT ABOUT 200 SQUARE METRES (2,153 SQUARE FEET) IN SIZE.

THE BUDDHA WAS ONE OF THE MAJOR SUBJECTS OF JAPANESE ART.

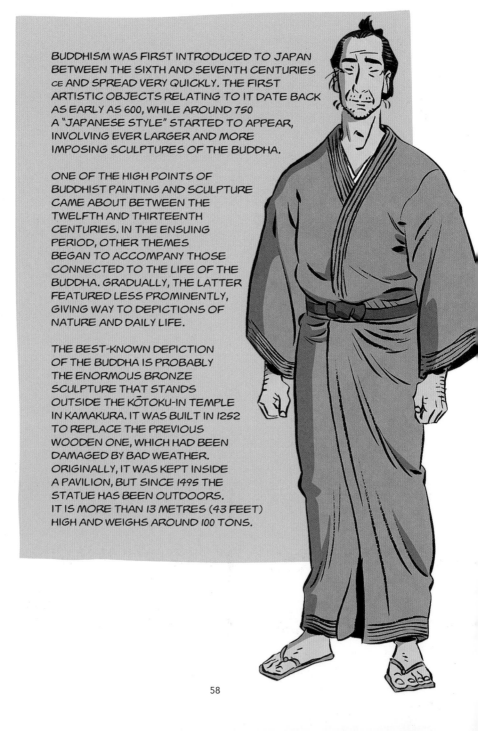

BUDDHISM WAS FIRST INTRODUCED TO JAPAN BETWEEN THE SIXTH AND SEVENTH CENTURIES CE AND SPREAD VERY QUICKLY. THE FIRST ARTISTIC OBJECTS RELATING TO IT DATE BACK AS EARLY AS 600, WHILE AROUND 750 A "JAPANESE STYLE" STARTED TO APPEAR, INVOLVING EVER LARGER AND MORE IMPOSING SCULPTURES OF THE BUDDHA.

ONE OF THE HIGH POINTS OF BUDDHIST PAINTING AND SCULPTURE CAME ABOUT BETWEEN THE TWELFTH AND THIRTEENTH CENTURIES. IN THE ENSUING PERIOD, OTHER THEMES BEGAN TO ACCOMPANY THOSE CONNECTED TO THE LIFE OF THE BUDDHA. GRADUALLY, THE LATTER FEATURED LESS PROMINENTLY, GIVING WAY TO DEPICTIONS OF NATURE AND DAILY LIFE.

THE BEST-KNOWN DEPICTION OF THE BUDDHA IS PROBABLY THE ENORMOUS BRONZE SCULPTURE THAT STANDS OUTSIDE THE KŌTOKU-IN TEMPLE IN KAMAKURA. IT WAS BUILT IN 1252 TO REPLACE THE PREVIOUS WOODEN ONE, WHICH HAD BEEN DAMAGED BY BAD WEATHER. ORIGINALLY, IT WAS KEPT INSIDE A PAVILION, BUT SINCE 1495 THE STATUE HAS BEEN OUTDOORS. IT IS MORE THAN 13 METRES (43 FEET) HIGH AND WEIGHS AROUND 100 TONS.

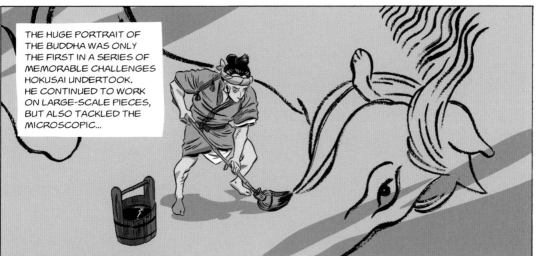

THE HUGE PORTRAIT OF THE BUDDHA WAS ONLY THE FIRST IN A SERIES OF MEMORABLE CHALLENGES HOKUSAI UNDERTOOK. HE CONTINUED TO WORK ON LARGE-SCALE PIECES, BUT ALSO TACKLED THE MICROSCOPIC...

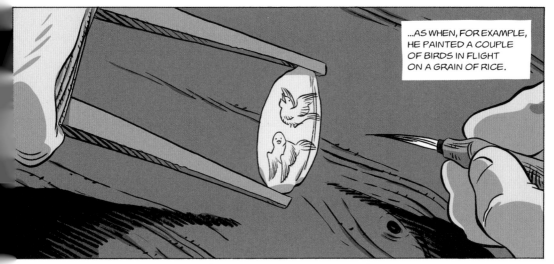

...AS WHEN, FOR EXAMPLE, HE PAINTED A COUPLE OF BIRDS IN FLIGHT ON A GRAIN OF RICE.

IF THE "MASS-PRODUCED" *UKIYO-E* PRINTS WERE MADE FOR THE PEOPLE, ORIGINAL ARTWORKS WERE THE PRESERVE OF THE WEALTHIER CLASSES, FROM THE MERCHANTS TO THE DAIMYO, ALL THE WAY UP TO THE EMPEROR, WHO SAT AT THE TOP OF THE SOCIAL PYRAMID.

ACCORDING TO TRADITION, **THE FIRST JAPANESE EMPEROR** CAME TO POWER IN 660 BCE AND REMAINED THERE UNTIL 585 BCE, WHEN HE DIED AT THE AGE OF 126. JIMMU, THE FIRST EMPEROR, IS OBVIOUSLY A MYTHOLOGICAL FIGURE – BUT HISTORY AND MYTH OFTEN INTERTWINE IN JAPAN, MAKING IT DIFFICULT TO ESTABLISH WHERE ONE ENDS AND THE OTHER BEGINS.

UNTIL THE END OF WORLD WAR II, THE EMPEROR WAS THE ABSOLUTE RULER AND CONSIDERED TO BE OF DIVINE ORIGIN; AFTER THE WAR THINGS CHANGED, AND TODAY THE EMPEROR IS A HEAD OF STATE WITH VERY LIMITED POWERS.

EMPEROR JIMMU WAS A DIRECT DESCENDANT OF AMATERASU, GODDESS OF THE SUN, AND SUSANOO, THE GOD OF STORMS. ACCORDING TO LEGEND, JIMMU FOLLOWED YATAGARASU, A THREE-LEGGED CROW OWNED BY AMATERASU, TO THE PLACE WHERE HE SHOULD LAY THE FOUNDATIONS OF HIS KINGDOM, NEAR OSAKA; THIS LED TO THE BIRTH OF AN EMPIRE WHICH, THOUGH IT HAS UNDERGONE MAJOR CHANGES OVER THE MILLENNIA, STILL STANDS TODAY.

AT THE BOTTOM OF THE SOCIAL PYRAMID – PUTTING ASIDE THE CASTE-LESS – WERE THE ARTISANS AND MERCHANTS WHO LIVED WITHIN THE CITY WALLS. ONE STEP ABOVE WERE THE FARMERS, BUT MOST PROMINENT OF ALL WAS THE MILITARY CASTE, COMPOSED OF THE SHOGUN (THE GENERAL, WHOSE TITLE WAS HEREDITARY), THE DAIMYO (FEUDAL LORDS UNDER THE SHOGUN'S COMMAND) AND THE SAMURAI (THE WARRIORS).

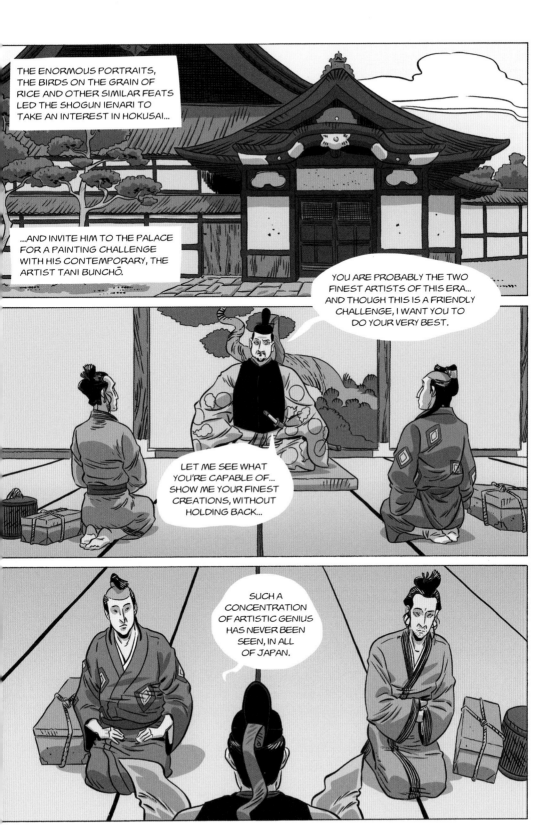

THE ENORMOUS PORTRAITS, THE BIRDS ON THE GRAIN OF RICE AND OTHER SIMILAR FEATS LED THE SHOGUN IENARI TO TAKE AN INTEREST IN HOKUSAI...

...AND INVITE HIM TO THE PALACE FOR A PAINTING CHALLENGE WITH HIS CONTEMPORARY, THE ARTIST TANI BUNCHŌ.

YOU ARE PROBABLY THE TWO FINEST ARTISTS OF THIS ERA... AND THOUGH THIS IS A FRIENDLY CHALLENGE, I WANT YOU TO DO YOUR VERY BEST.

LET ME SEE WHAT YOU'RE CAPABLE OF... SHOW ME YOUR FINEST CREATIONS, WITHOUT HOLDING BACK...

SUCH A CONCENTRATION OF ARTISTIC GENIUS HAS NEVER BEEN SEEN, IN ALL OF JAPAN.

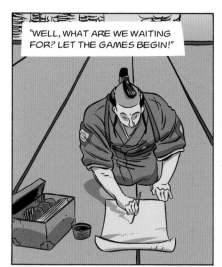

"WELL, WHAT ARE WE WAITING FOR? LET THE GAMES BEGIN!"

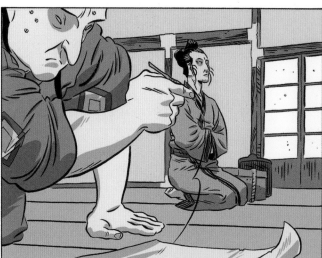

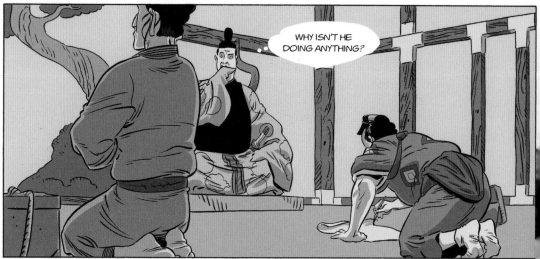

WHY ISN'T HE DOING ANYTHING?

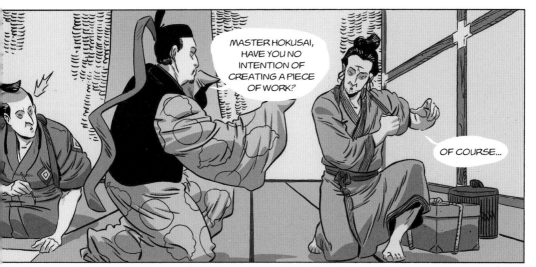

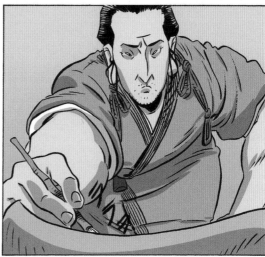

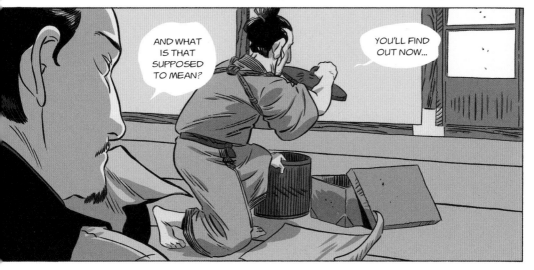

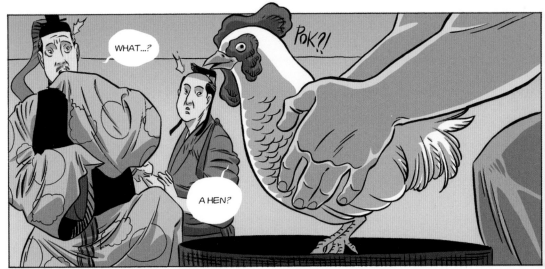

WHAT...?

POK?!

A HEN?

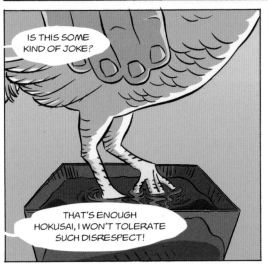

IS THIS SOME KIND OF JOKE?

THAT'S ENOUGH HOKUSAI, I WON'T TOLERATE SUCH DISRESPECT!

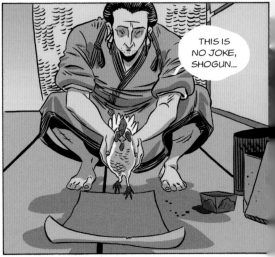

THIS IS NO JOKE, SHOGUN...

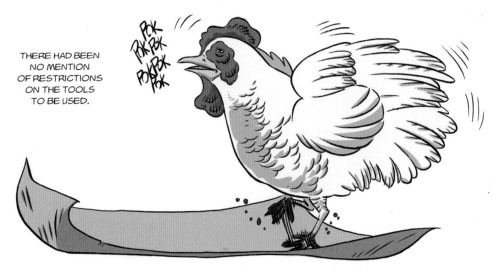

THERE HAD BEEN NO MENTION OF RESTRICTIONS ON THE TOOLS TO BE USED.

POK POK POK POK POK

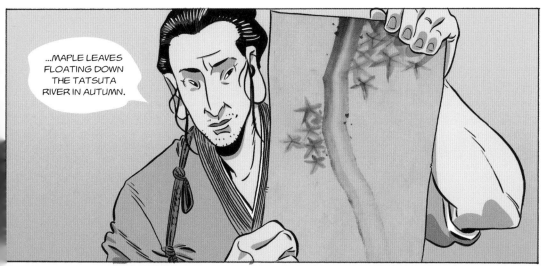

...MAPLE LEAVES FLOATING DOWN THE TATSUTA RIVER IN AUTUMN.

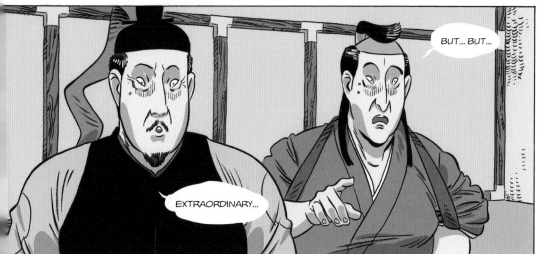

BUT... BUT...

EXTRAORDINARY...

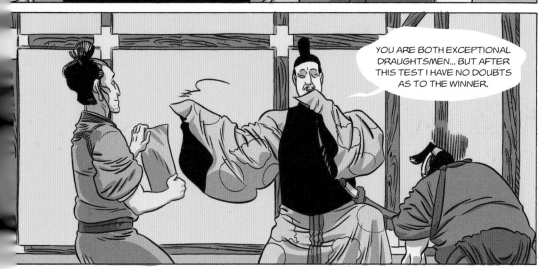

YOU ARE BOTH EXCEPTIONAL DRAUGHTSMEN... BUT AFTER THIS TEST I HAVE NO DOUBTS AS TO THE WINNER.

UKIYO-E IS THE MOST WELL-KNOWN TYPE OF **WOODBLOCK PRINTING** IN JAPANESE ART. IT INVOLVES THE CARVING OF WOODEN BLOCKS TO WHICH INK IS THEN APPLIED AND, THANKS TO THE RELIEFS CUT INTO THE BLOCKS, THE IMAGE CAN BE PRINTED ON PAPER.

THE DURABILITY OF THE BLOCKS MEANS THAT A RELATIVELY HIGH NUMBER OF COPIES CAN BE MADE, AND THIS ALLOWED FOR MASS PRODUCTION WELL BEFORE THE ADVENT OF THE PRINTING PRESS.

SILKSCREEN PRINTING, ON THE OTHER HAND, IS A TECHNIQUE THAT USES A PIECE OF FABRIC LIKE A MOULD, AFTER SOME PARTS OF IT HAVE BEEN WATERPROOFED.

THIS FABRIC IS THEN SPREAD OVER THE SURFACE TO BE PRINTED (WHETHER PAPER OR ANOTHER MEDIUM) AND THE INK IS APPLIED USING SPECIFIC TECHNIQUES. THANKS TO THE WATERPROOFED SECTIONS, THE INK ONLY SEEPS THROUGH CERTAIN PARTS OF THE FABRIC, THUS CREATING THE DESIRED IMAGE ON THE SURFACE BELOW.

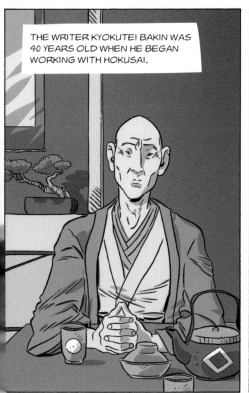

THE WRITER KYOKUTEI BAKIN WAS 40 YEARS OLD WHEN HE BEGAN WORKING WITH HOKUSAI.

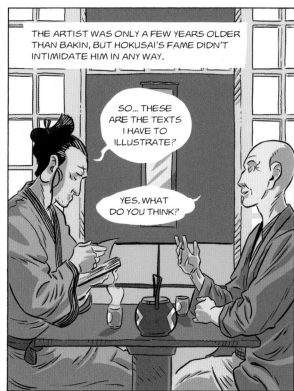

THE ARTIST WAS ONLY A FEW YEARS OLDER THAN BAKIN, BUT HOKUSAI'S FAME DIDN'T INTIMIDATE HIM IN ANY WAY.

SO... THESE ARE THE TEXTS I HAVE TO ILLUSTRATE?

YES. WHAT DO YOU THINK?

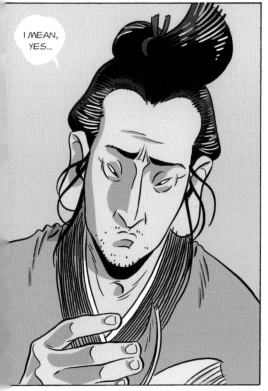

I MEAN, YES...

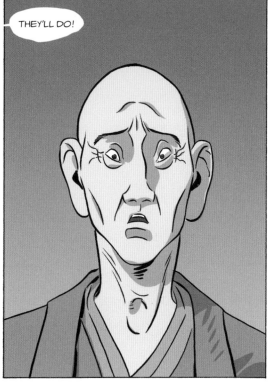

THEY'LL DO!

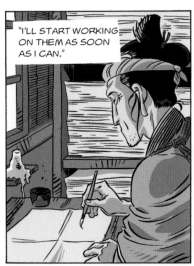

"I'LL START WORKING ON THEM AS SOON AS I CAN."

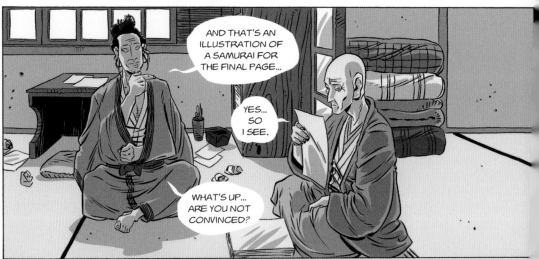

AND THAT'S AN ILLUSTRATION OF A SAMURAI FOR THE FINAL PAGE...

YES... SO I SEE.

WHAT'S UP... ARE YOU NOT CONVINCED?

NO, NO... THEY'RE FINE...

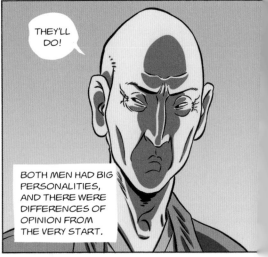

THEY'LL DO!

BOTH MEN HAD BIG PERSONALITIES, AND THERE WERE DIFFERENCES OF OPINION FROM THE VERY START.

THE **SAMURAI** WERE THE WARRIOR CASTE OF ANCIENT JAPAN, AND AMONG THE MOST FREQUENTLY DEPICTED SUBJECTS OF THE PERIOD, AS WELL AS THE HEROES OF WIDELY READ STORIES. THE TERM SAMURAI MEANS "MEN WHO SERVE NOBLES", BUT THEIR ROLE WASN'T SOLELY MILITARY.

AS WELL AS MARTIAL ARTS, THE SAMURAI WERE MASTERS IN THE ARTS OF ZEN AND WRITING: INDEED, PHYSICAL SKILL WENT HAND IN HAND WITH MENTAL ABILITY FOR THEM.

EVERY SAMURAI WAS IN THE SERVICE OF A DAIMYO (A FEUDAL LORD) WHOM HE PROTECTED AND FROM WHOM HE RECEIVED HIS ASSIGNMENTS. IN THE EVENT THAT HE LOST THE TRUST OF HIS DAIMYO, OR IF THE LATTER DIED, THE SAMURAI BECAME A **RONIN**, A WARRIOR WITHOUT A MASTER.

IN EITHER CASE THE *BUSHIDO*, THE CODE OF THE WARRIOR CASTE, DICTATED THAT THE SAMURAI HAD TO PERFORM RITUAL SUICIDE. UNDERSTANDABLY, HOWEVER, AFTER THE LOSS OF THEIR DAIMYO, MANY PREFERRED TO SET OFF AS ROAMING WARRIORS. THEY COULD WORK AS MERCENARIES, BUT THEIR HONOUR WAS IRREDEEMABLY COMPROMISED. EVEN THOUGH THE TERM *RONIN* SIMPLY MEANS "FREE FROM CONSTRAINTS", IT HAD OFFENSIVE CONNOTATIONS.

ALTHOUGH THE SAMURAI WERE KNOWN FOR THEIR USE OF THE *KATANA*, THE TRADITIONAL JAPANESE SWORD, THEY USED ALL KINDS OF WEAPONS: KNIVES, SWORDS, DAGGERS, BOWS AND ARROWS... ONLY FIREARMS WERE CONSIDERED DISHONOURABLE AND THEREFORE NOT USED.

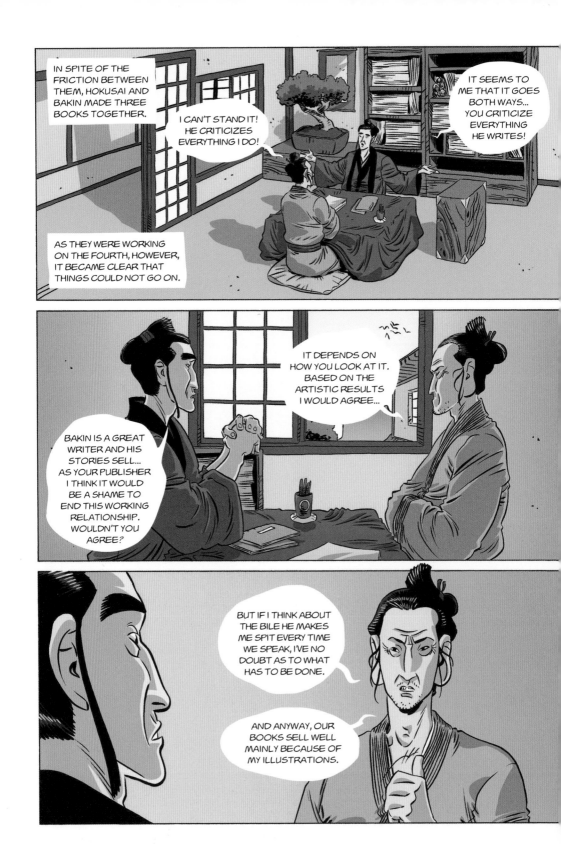

IN SPITE OF THE FRICTION BETWEEN THEM, HOKUSAI AND BAKIN MADE THREE BOOKS TOGETHER.

I CAN'T STAND IT! HE CRITICIZES EVERYTHING I DO!

IT SEEMS TO ME THAT IT GOES BOTH WAYS... YOU CRITICIZE EVERYTHING HE WRITES!

AS THEY WERE WORKING ON THE FOURTH, HOWEVER, IT BECAME CLEAR THAT THINGS COULD NOT GO ON.

IT DEPENDS ON HOW YOU LOOK AT IT. BASED ON THE ARTISTIC RESULTS I WOULD AGREE...

BAKIN IS A GREAT WRITER AND HIS STORIES SELL... AS YOUR PUBLISHER I THINK IT WOULD BE A SHAME TO END THIS WORKING RELATIONSHIP. WOULDN'T YOU AGREE?

BUT IF I THINK ABOUT THE BILE HE MAKES ME SPIT EVERY TIME WE SPEAK, I'VE NO DOUBT AS TO WHAT HAS TO BE DONE.

AND ANYWAY, OUR BOOKS SELL WELL MAINLY BECAUSE OF MY ILLUSTRATIONS.

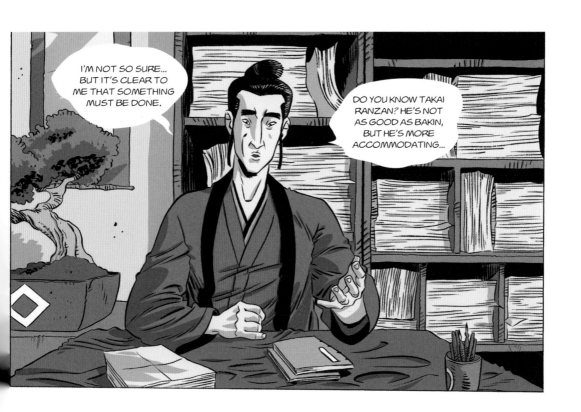

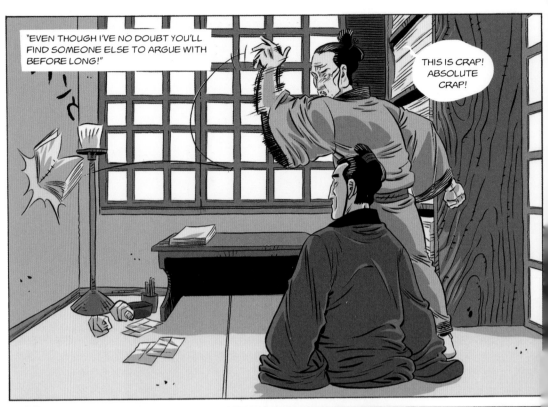

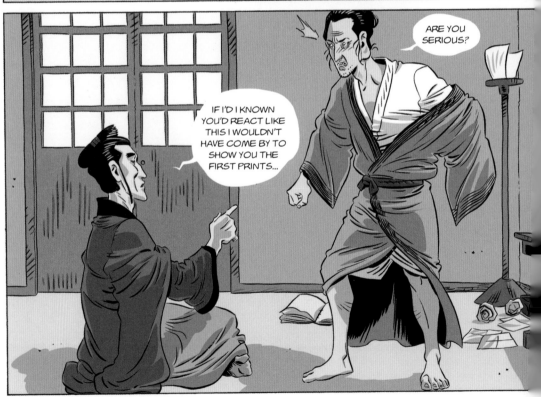

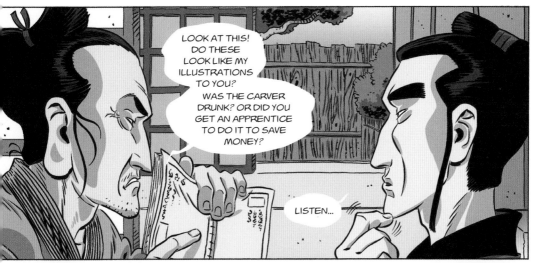

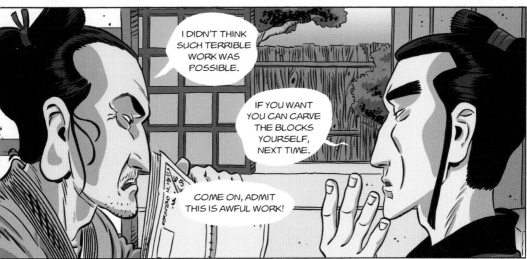

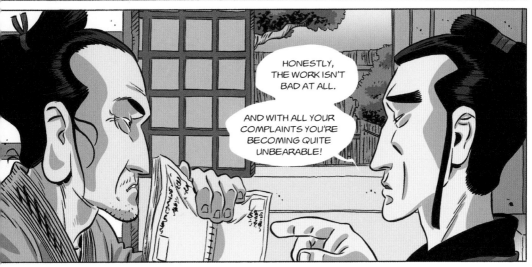

HOKUSAI WAS WELL AWARE OF HIS GREATNESS,
BUT HE WAS ALWAYS ON THE LOOKOUT FOR NEW
WAYS OF IMPROVING HIS STYLE. HAVING LEARNED
TO PAINT AT A YOUNG AGE AND ACCORDING TO THE
CLASSICAL CONVENTIONS OF JAPANESE PAINTING
AT THE TIME – IN WHICH THE INFLUENCE OF CHINESE
ART WAS VERY STRONG – HE STARTED TO DRAW
INSPIRATION FROM EUROPEAN ART, BLENDING
THE TWO TO SUIT JAPANESE TASTES.

AROUND THE AGE OF 25, HE HAD ALREADY LEARNED TO USE
PERSPECTIVE TO MAKE HIS WORK THREE-DIMENSIONAL,
AS MANY OF HIS ARTISTIC CONTEMPORARIES HAD, AND HE
CONSTANTLY PURSUED HIS STUDY OF REALITY, OF FORMS
AND PICTORIAL TECHNIQUE.

HOKUSAI PAINTED HIS ENTIRE LIFE AND HE CONTINUED
TO REFINE HIS TECHNIQUE FURTHER UNTIL HIS LAST YEARS.

HE WAS ALSO EXTREMELY GOOD AT PROMOTING HIS
OWN WORK, EVEN THOUGH HE WAS OFTEN DISSATISFIED
WITH IT. ALTHOUGH TODAY HIS WORKS ARE UNIVERSALLY
CONSIDERED MASTERPIECES, HE WAS CONTINUOUSLY
ON THE HUNT FOR ARTISTIC PERFECTION – A PERFECTION
WHICH, IN HIS OPINION, HE NEVER ACHIEVED.

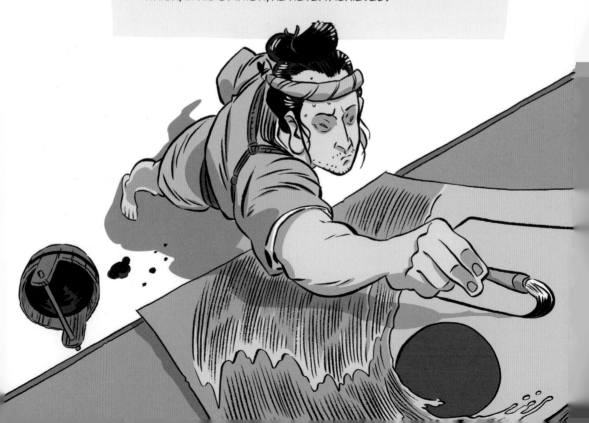

IN THE FOLLOWING YEARS,
HOKUSAI BEGAN A NEW KIND OF
ARTISTIC OUTPUT, IN A GENRE
RATHER DIFFERENT TO THOSE
WITH WHICH HE HAD PREVIOUSLY
BEEN ASSOCIATED.

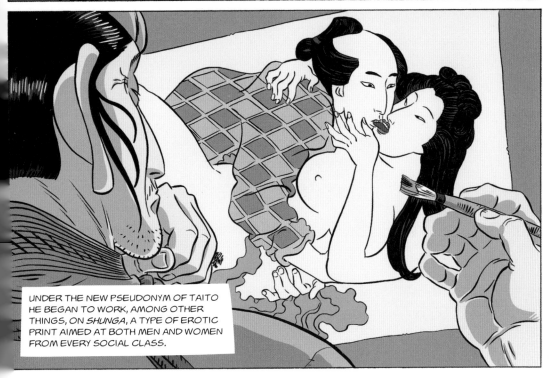

UNDER THE NEW PSEUDONYM OF TAITO
HE BEGAN TO WORK, AMONG OTHER
THINGS, ON *SHUNGA*, A TYPE OF EROTIC
PRINT AIMED AT BOTH MEN AND WOMEN
FROM EVERY SOCIAL CLASS.

THE PERIOD IN WHICH HOKUSAI
WORKED UNDER THE NAME TAITO
WAS CERTAINLY NOT ONE OF THE
MOST PROLIFIC OF HIS CAREER,
BUT IT PRODUCED IMAGES OF
AN EXTREMELY HIGH QUALITY.

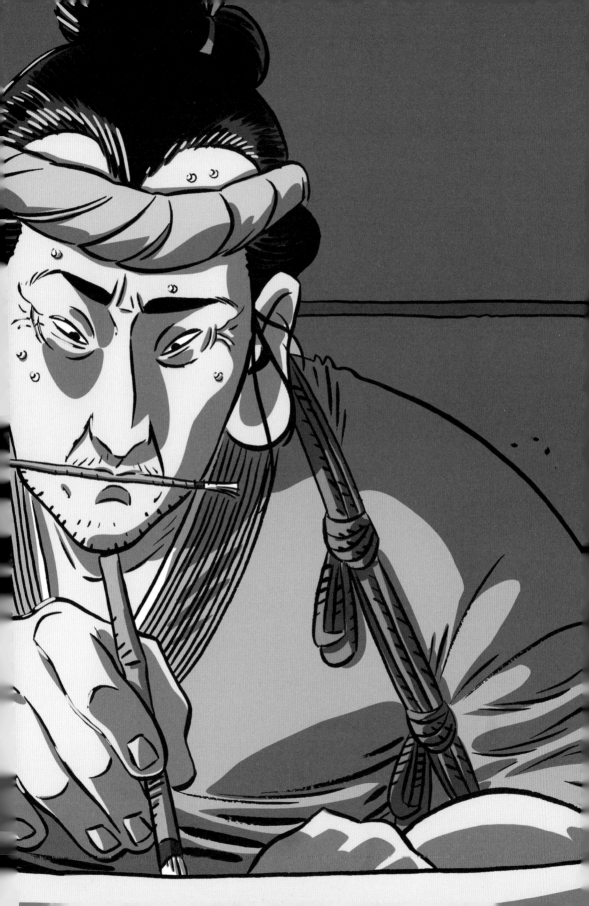

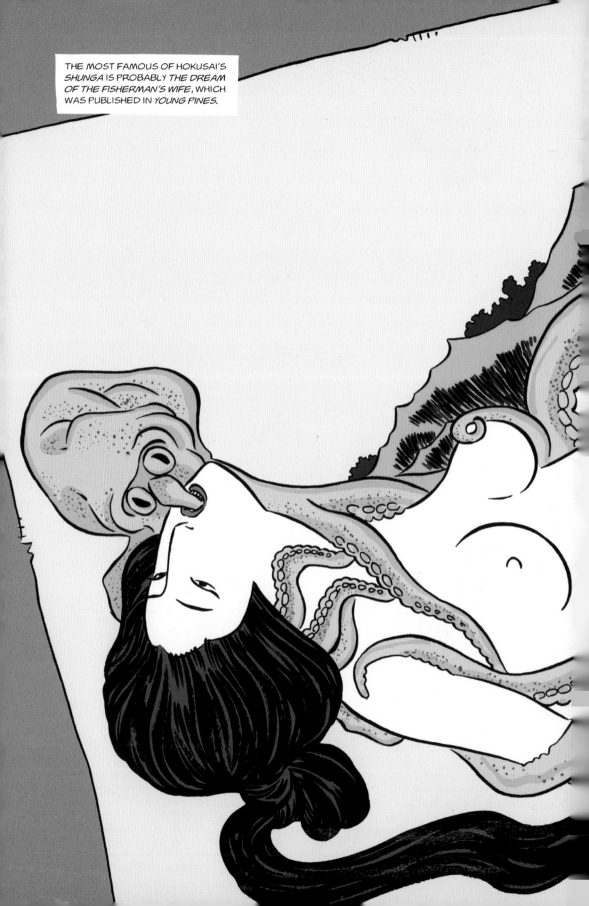

THE MOST FAMOUS OF HOKUSAI'S *SHUNGA* IS PROBABLY *THE DREAM OF THE FISHERMAN'S WIFE*, WHICH WAS PUBLISHED IN *YOUNG PINES*.

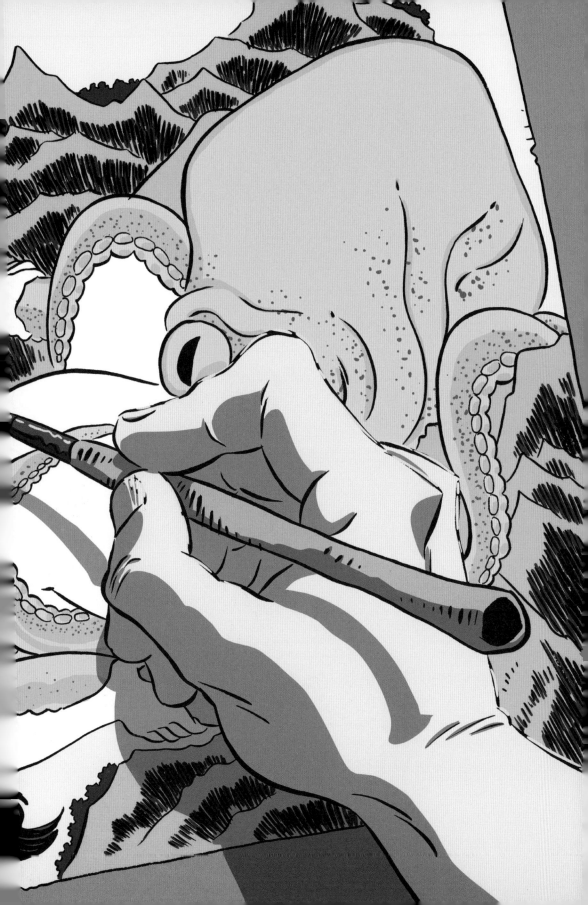

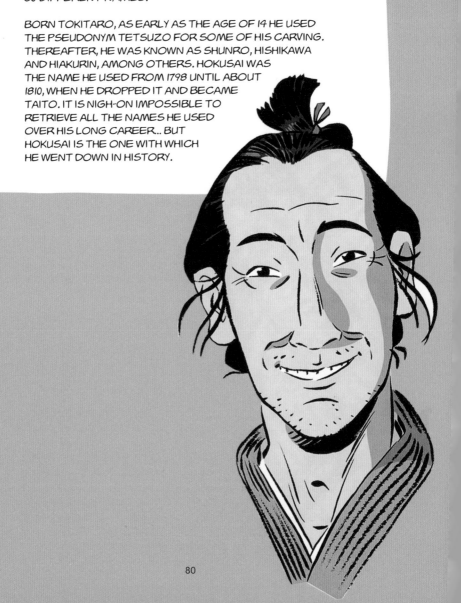

CHANGING ONE'S NAME WAS FAIRLY COMMON PRACTICE
FOR JAPANESE ARTISTS. WHEN THEY JOINED A PARTICULAR
SCHOOL, THEIR MASTER WOULD OFTEN GRANT THEM
A PART OF THEIR NAME, AND SOMETIMES NAMES WOULD
BE HANDED DOWN FROM MASTER TO PUPIL.

HOKUSAI IS NO EXCEPTION AND, OVER THE COURSE OF
HIS CAREER, HE ADOPTED A HUGE NUMBER OF DIFFERENT
NAMES. HIS IS SOMETHING OF A RECORD IN THIS REGARD,
HOWEVER, GIVEN THAT HE WAS KNOWN BY AT LEAST
30 DIFFERENT NAMES.

BORN TOKITARO, AS EARLY AS THE AGE OF 14 HE USED
THE PSEUDONYM TETSUZO FOR SOME OF HIS CARVING.
THEREAFTER, HE WAS KNOWN AS SHUNRO, HISHIKAWA
AND HIAKURIN, AMONG OTHERS. HOKUSAI WAS
THE NAME HE USED FROM 1798 UNTIL ABOUT
1810, WHEN HE DROPPED IT AND BECAME
TAITO. IT IS NIGH-ON IMPOSSIBLE TO
RETRIEVE ALL THE NAMES HE USED
OVER HIS LONG CAREER... BUT
HOKUSAI IS THE ONE WITH WHICH
HE WENT DOWN IN HISTORY.

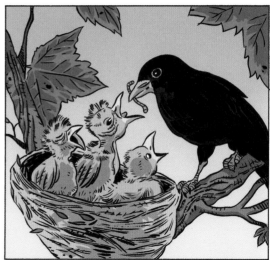

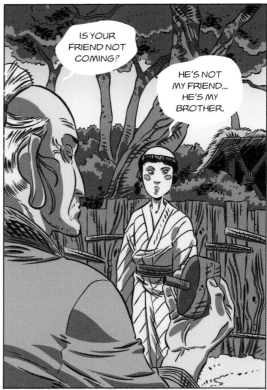

IS YOUR FRIEND NOT COMING?

HE'S NOT MY FRIEND... HE'S MY BROTHER.

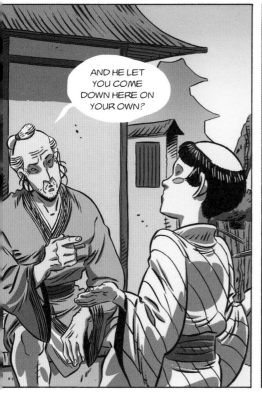

AND HE LET YOU COME DOWN HERE ON YOUR OWN?

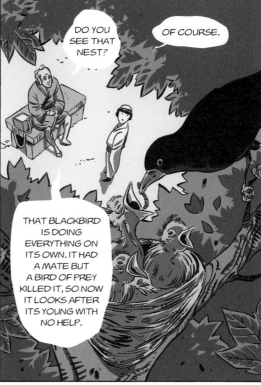

DO YOU SEE THAT NEST?

OF COURSE.

THAT BLACKBIRD IS DOING EVERYTHING ON ITS OWN. IT HAD A MATE BUT A BIRD OF PREY KILLED IT, SO NOW IT LOOKS AFTER ITS YOUNG WITH NO HELP.

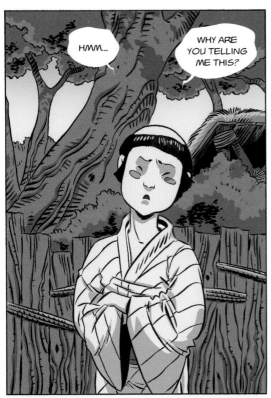

HMM...

WHY ARE YOU TELLING ME THIS?

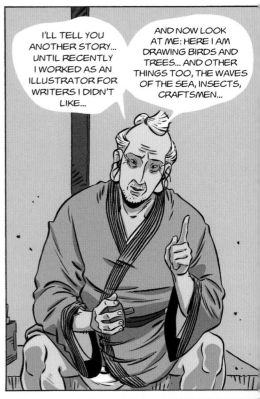

I'LL TELL YOU ANOTHER STORY... UNTIL RECENTLY I WORKED AS AN ILLUSTRATOR FOR WRITERS I DIDN'T LIKE...

AND NOW LOOK AT ME: HERE I AM DRAWING BIRDS AND TREES... AND OTHER THINGS TOO, THE WAVES OF THE SEA, INSECTS, CRAFTSMEN...

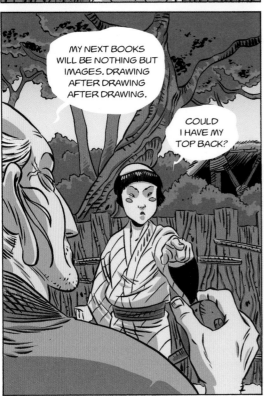

MY NEXT BOOKS WILL BE NOTHING BUT IMAGES. DRAWING AFTER DRAWING AFTER DRAWING.

COULD I HAVE MY TOP BACK?

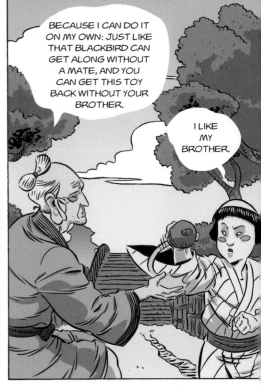

BECAUSE I CAN DO IT ON MY OWN: JUST LIKE THAT BLACKBIRD CAN GET ALONG WITHOUT A MATE, AND YOU CAN GET THIS TOY BACK WITHOUT YOUR BROTHER.

I LIKE MY BROTHER.

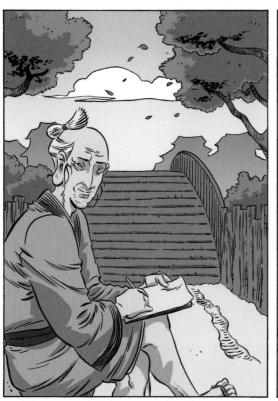

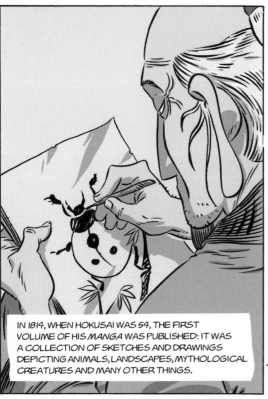

IN 1814, WHEN HOKUSAI WAS 54, THE FIRST VOLUME OF HIS *MANGA* WAS PUBLISHED: IT WAS A COLLECTION OF SKETCHES AND DRAWINGS DEPICTING ANIMALS, LANDSCAPES, MYTHOLOGICAL CREATURES AND MANY OTHER THINGS.

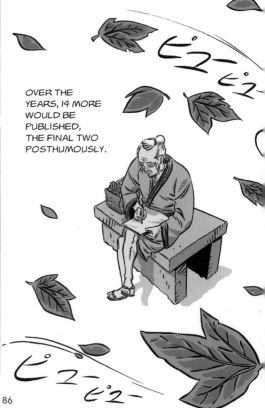

OVER THE YEARS, 14 MORE WOULD BE PUBLISHED, THE FINAL TWO POSTHUMOUSLY.

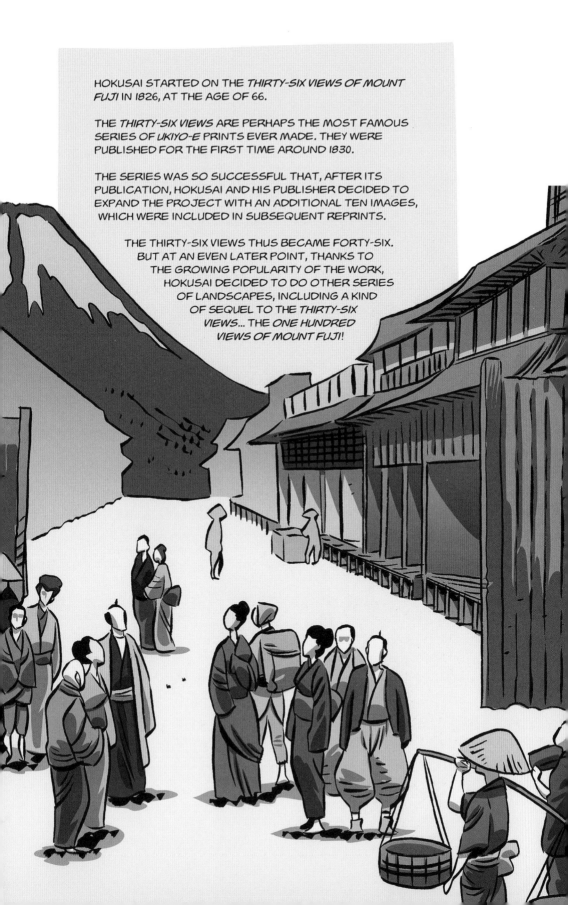

HOKUSAI STARTED ON THE *THIRTY-SIX VIEWS OF MOUNT FUJI* IN 1826, AT THE AGE OF 66.

THE *THIRTY-SIX VIEWS* ARE PERHAPS THE MOST FAMOUS SERIES OF *UKIYO-E* PRINTS EVER MADE. THEY WERE PUBLISHED FOR THE FIRST TIME AROUND 1830.

THE SERIES WAS SO SUCCESSFUL THAT, AFTER ITS PUBLICATION, HOKUSAI AND HIS PUBLISHER DECIDED TO EXPAND THE PROJECT WITH AN ADDITIONAL TEN IMAGES, WHICH WERE INCLUDED IN SUBSEQUENT REPRINTS.

THE THIRTY-SIX VIEWS THUS BECAME FORTY-SIX. BUT AT AN EVEN LATER POINT, THANKS TO THE GROWING POPULARITY OF THE WORK, HOKUSAI DECIDED TO DO OTHER SERIES OF LANDSCAPES, INCLUDING A KIND OF SEQUEL TO THE *THIRTY-SIX VIEWS*... THE *ONE HUNDRED VIEWS OF MOUNT FUJI*!

AT 3,776 METRES (12,389 FEET), MOUNT FUJI IS THE HIGHEST MOUNTAIN IN JAPAN. IT OWES ITS REGULAR, CONICAL SHAPE TO ITS ORIGIN AS A VOLCANO, WHICH LAST ERUPTED IN 1708.

GIVEN ITS HEIGHT, IT CAN BE SEEN FROM VERY FAR AWAY – HENCE IT IS OFTEN DEPICTED IN THE BACKGROUND OF LANDSCAPES AND POSTCARDS.

MOUNT FUJI HAS A PARTICULAR EMOTIONAL SIGNIFICANCE FOR THE JAPANESE. IN THE PAST, IT WAS AN IMPORTANT RELIGIOUS SYMBOL, AND IS STILL A PILGRIMAGE SITE FOR SHINTOISTS TODAY.

ITS SUMMIT IS ALMOST ALWAYS COVERED WITH SNOW: IN LATE SPRING IT'S BARE, BUT IT TURNS WHITE AGAIN ALMOST AS SOON AS THE SUMMER ENDS, REMAINING CONCEALED UNTIL THE FOLLOWING MAY.

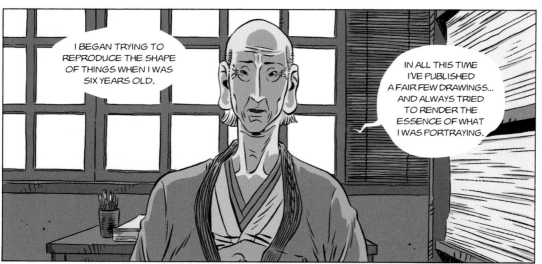

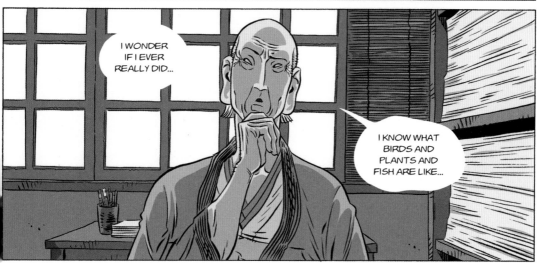

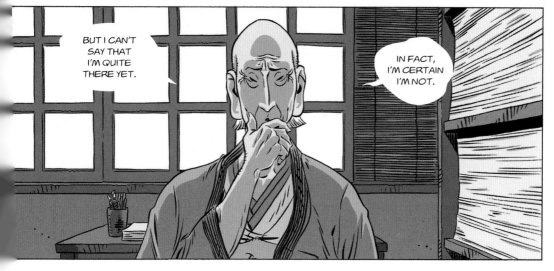

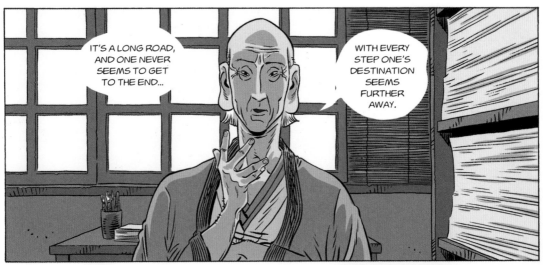

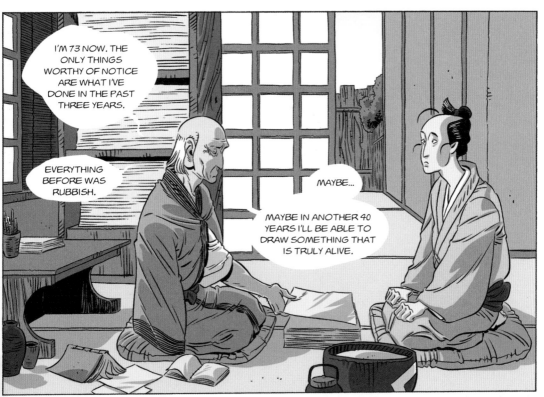

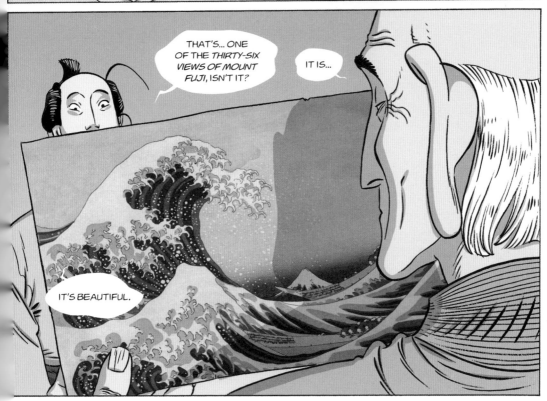

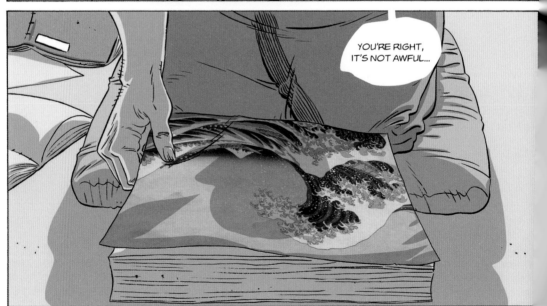

92

UNDER THE GREAT WAVE OFF KANAGAWA IS ONE OF THE MOST FAMOUS AND REFERENCED IMAGES IN THE WORLD. IT IS THE FIRST OF THE *THIRTY-SIX VIEWS OF MOUNT FUJI* AND SHOWS THREE TYPICAL FISHING BOATS AT THE MERCY OF A TERRIFYING WAVE FOLDING OVER ITSELF LIKE A CLAW.

MOUNT FUJI CAN BE SEEN IN THE BACKGROUND IN THE DISTANCE, PERFECTLY POSITIONED AT THE CENTRE OF THE ARC FORMED BY THE WAVE.

ONLY A FEW IMPRESSIONS OF THIS GREAT WOODBLOCK HAVE SURVIVED TO THE PRESENT DAY, PRESERVED IN SOME OF THE WORLD'S MAJOR MUSEUMS. COPIES CAN BE FOUND IN ITALY (AT THE CIVICO MUSEO D'ARTE ORIENTALE IN TRIESTE, AND AT THE MUSEO D'ARTE ORIENTALE IN TURIN); IN FRANCE (AT THE BIBLIOTHÈQUE NATIONALE DE FRANCE IN PARIS); IN THE UK (AT THE BRITISH MUSEUM AND AT THE VICTORIA AND ALBERT MUSEUM IN LONDON); IN THE UNITED STATES (AT THE MET IN NEW YORK AND THE MUSEUM OF FINE ARTS IN BOSTON); IN GERMANY (AT THE MUSEUM FÜR KUNST UND GEWERBE IN HAMBURG) – AS WELL AS IN MANY OTHER COUNTRIES.

TO A WESTERN OBSERVER USED TO READING A PAINTING FROM LEFT TO RIGHT, IT MIGHT APPEAR THAT THE WAVE IS RISING BEHIND THE FISHERMEN. HOWEVER, IT IS WORTH NOTING THAT THE JAPANESE VIEWER WOULD READ FROM RIGHT TO LEFT: THE SENSE, THEN, IS THAT THE WAVE IS ABOUT TO HIT THE BOATS HEAD-ON, STOPPING THEM IN THEIR TRACKS.

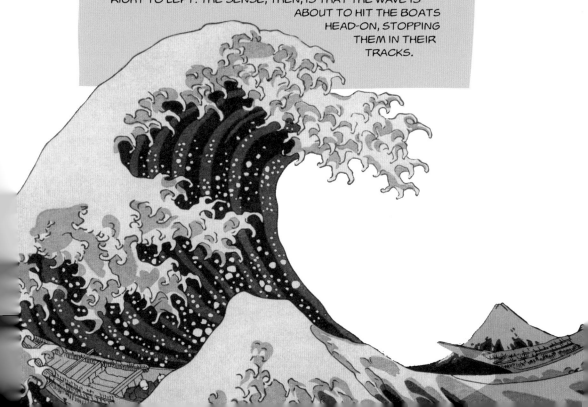

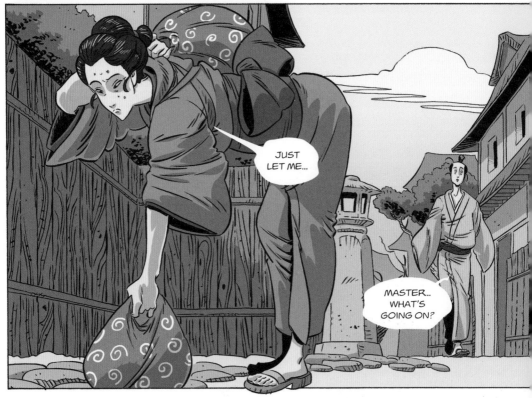

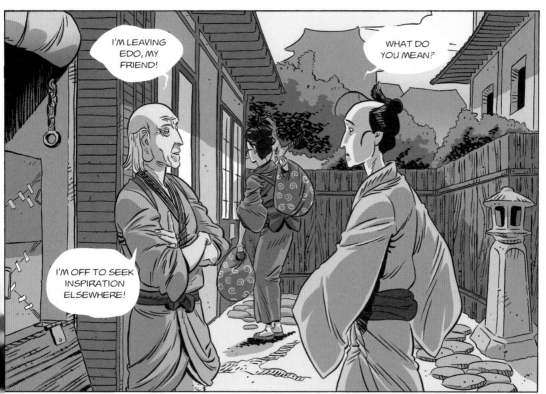

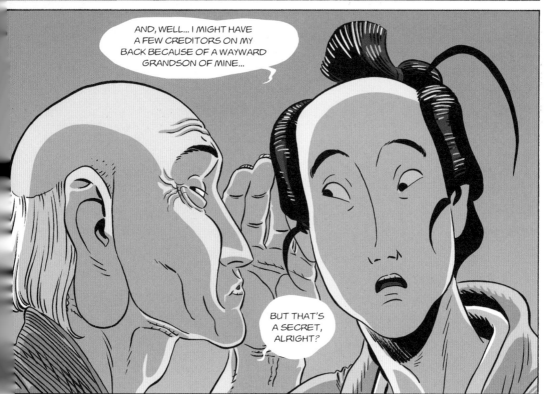

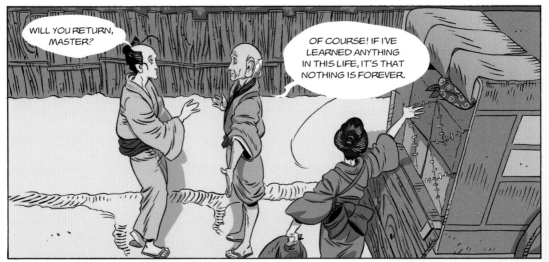

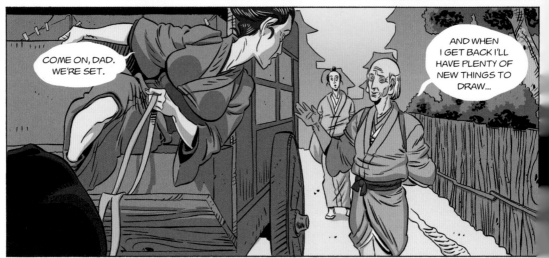

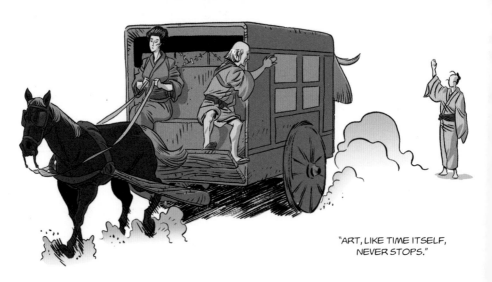

"ART, LIKE TIME ITSELF, NEVER STOPS."

OVER THE CENTURIES, THE FEATURES AND SUBJECTS
OF JAPANESE PAINTING HAVE UNDERGONE A SLOW,
CONTINUOUS EVOLUTION. FROM THE ADVENT OF
BUDDHISM, AND FOR SEVERAL HUNDRED YEARS
THEREAFTER, ITS PRINCIPAL SUBJECTS WERE SCENES
FROM THE LIFE OF THE BUDDHA. HOWEVER, AROUND THE
NINTH CENTURY SOMETHING BEGAN TO CHANGE, LARGELY
THANKS TO THE INTRODUCTION OF THE *YAMATO-E* STYLE,
WHICH FAVOURED DEPICTIONS OF NATURE.

FROM THAT MOMENT ON, THE NATURAL WORLD – ANIMALS,
LANDSCAPES, THE CHANGING SEASONS – EARNED A
CENTRAL PLACE IN JAPANESE PAINTING. THESE ELEMENTS
HAVE BEEN AT THE HEART OF THE NATION'S ART FOR OVER
A THOUSAND YEARS, BUT IN THE LAST COUPLE OF HUNDRED
YEARS IT HAS OPENED UP TO REPRESENTATIONS OF TRADES
AND DAILY LIFE.

FROM ABOUT 1800 ONWARDS, AND MUCH MORE
SIGNIFICANTLY AFTER THE END OF THE POLICY OF
ISOLATION IN 1853, JAPANESE ART BEGAN TO ABSORB
TECHNIQUES, THEMES AND SUBJECTS HITHERTO
TYPICAL OF WESTERN CREATIONS, ARTISTS THROWING
THEMSELVES HEADLONG INTO THE FUTURE.

YAMATO-E IS CONSIDERED THE CLASSICAL JAPANESE
PAINTING STYLE. IT BEGAN TO FLOURISH PRIMARILY
DURING THE HEIAN PERIOD (794–1185) AND, THOUGH
INITIALLY INFLUENCED BY CHINESE ART, IT SOON
STARTED TO EXPLORE NEW GROUND, FORGING
ITS OWN DISTINCTIVE PATH. *YAMATO-E* HAD AN
ENORMOUS INFLUENCE ON THE STYLES OF
SUBSEQUENT PERIODS, INCLUDING *UKIYO-E*.

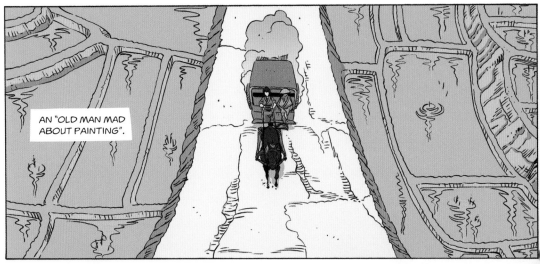

AN "OLD MAN MAD ABOUT PAINTING".

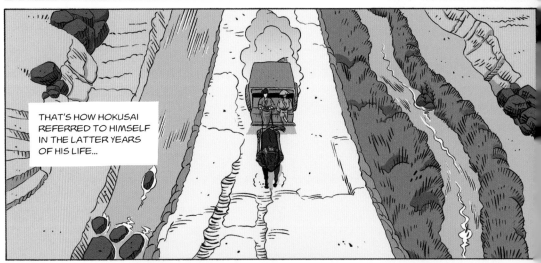

THAT'S HOW HOKUSAI REFERRED TO HIMSELF IN THE LATTER YEARS OF HIS LIFE...

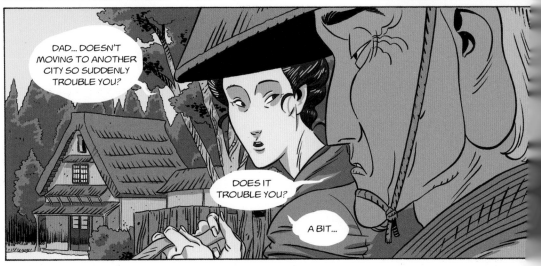

DAD... DOESN'T MOVING TO ANOTHER CITY SO SUDDENLY TROUBLE YOU?

DOES IT TROUBLE YOU?

A BIT...

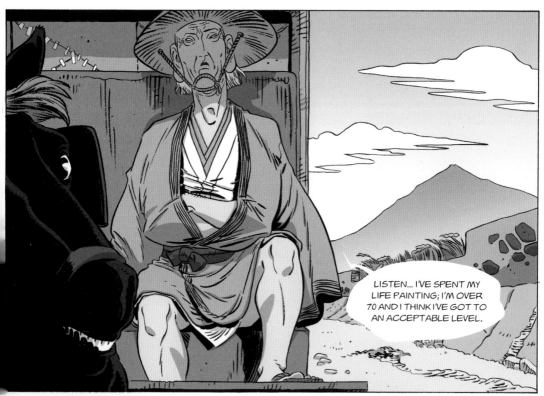

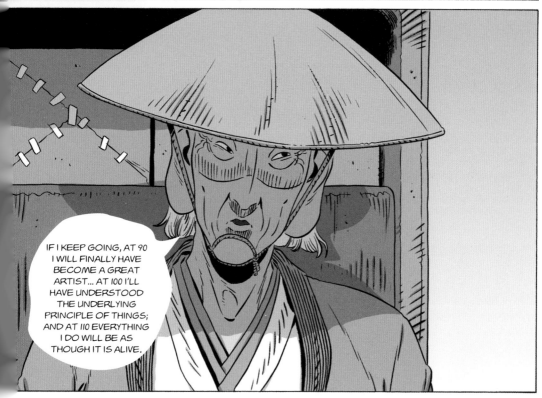

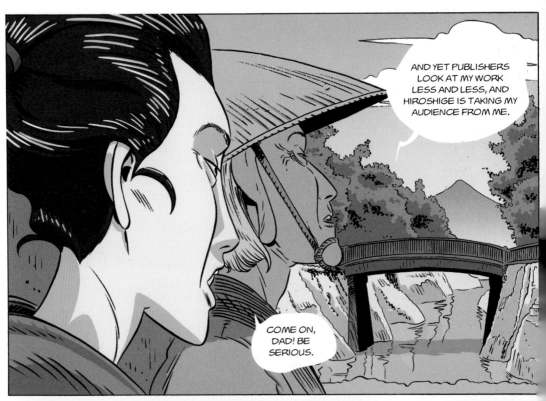

HOKUSAI'S LONG CAREER LED HIM TO WORK IN A WIDE VARIETY OF GENRES. THESE ARE THE ONES FOR WHICH HE IS BEST KNOWN.

UKIYO-E. THE STYLE OF PRINT TYPICAL OF THE EDO PERIOD, WHICH PORTRAYED GEISHAS, KABUKI ACTORS, SUMO WRESTLERS AND, MORE GENERALLY, THE WORLDS OF ENTERTAINMENT AND PERFORMANCE.

ILLUSTRATED POSTCARDS. ONE OF HOKUSAI'S PRINCIPAL ACTIVITIES AROUND THE AGE OF 30 WAS DRAWING *SURIMONO* – POSTCARDS DESIGNED TO CELEBRATE ALL KINDS OF OCCASIONS.

SATIRE. AGAIN AROUND THE AGE OF 30, HOKUSAI DREW ILLUSTRATIONS, AND IN SOME CASES ALSO WROTE THE TEXT, FOR A WIDE RANGE OF *KYOKA EHON*, SATIRICAL PAMPHLETS THAT WERE EXTREMELY POPULAR AT THE TIME.

SHUNGA. THE EROTIC ART HOKUSAI WORKED ON AROUND THE AGE OF 50, AND OF WHICH HE MADE SEVERAL ILLUSTRATED BOOKS OF A RATHER EXPLICIT NATURE.

MANGA. FROM THE AGE OF 55, HOKUSAI PUBLISHED A TOTAL OF 15 BOOKS FEATURING SERIES OF DRAWINGS OF NATURE, SCENES OF DAILY LIFE AND CREATURES FROM THE FOLK TRADITION.

MANUALS. IN THE SECOND HALF OF HIS LIFE, HOKUSAI ALSO WROTE SEVERAL DRAUGHTSMANSHIP AND PAINTING MANUALS, WHICH AIMED TO TEACH TECHNIQUES TO YOUNG PEOPLE WANTING TO LEARN THE CRAFT.

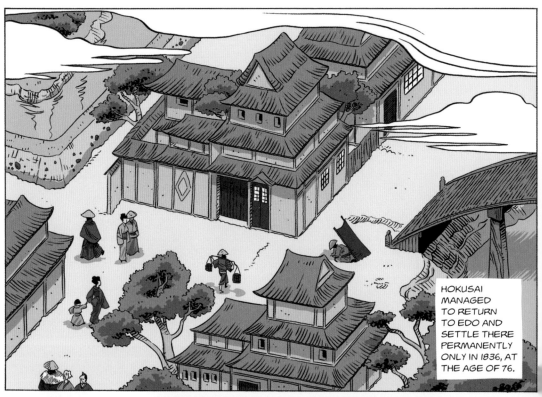

HOKUSAI MANAGED TO RETURN TO EDO AND SETTLE THERE PERMANENTLY ONLY IN 1836, AT THE AGE OF 76.

HIS FINANCIAL SITUATION CERTAINLY WASN'T ROSY, BUT THREE YEARS LATER ANOTHER EVENT ONLY INCREASED HIS PROBLEMS...

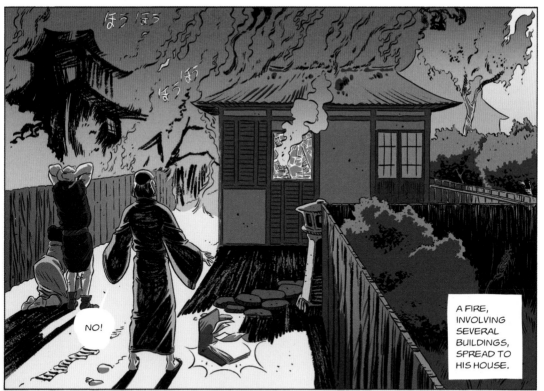

A FIRE, INVOLVING SEVERAL BUILDINGS, SPREAD TO HIS HOUSE.

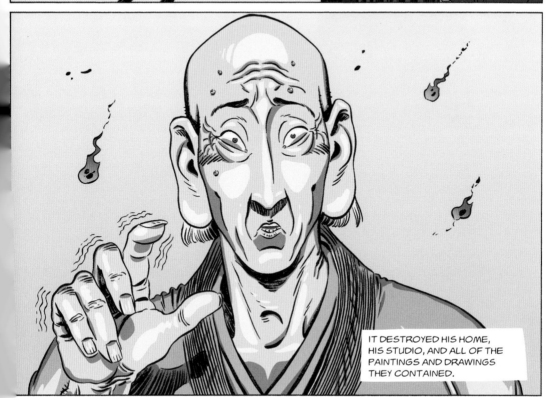

IT DESTROYED HIS HOME, HIS STUDIO, AND ALL OF THE PAINTINGS AND DRAWINGS THEY CONTAINED.

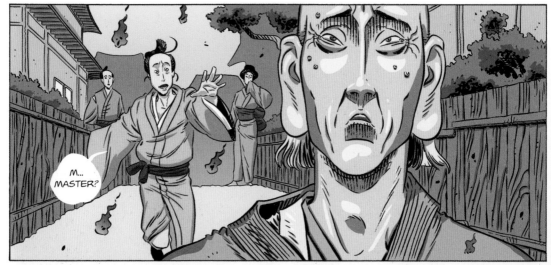

M...
MASTER?

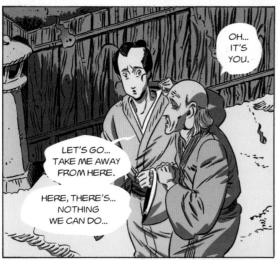

OH...
IT'S
YOU.

LET'S GO...
TAKE ME AWAY
FROM HERE.

HERE, THERE'S...
NOTHING
WE CAN DO...

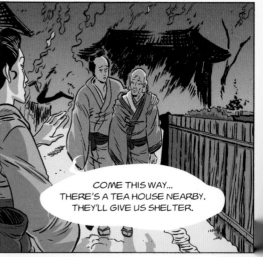

COME THIS WAY...
THERE'S A TEA HOUSE NEARBY.
THEY'LL GIVE US SHELTER.

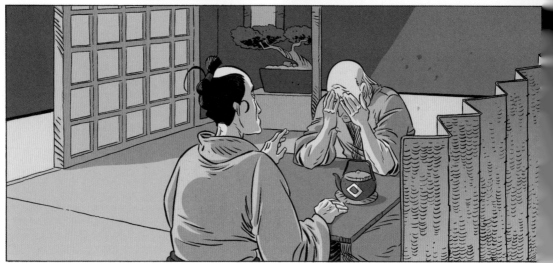

THE **TEA CEREMONY** IS ONE OF THE RITUALS FROM THE ZEN TRADITION BEST KNOWN IN THE WEST. IT IS BOTH A SOCIAL AND SPIRITUAL RITUAL, INVOLVING THE PREPARATION AND DRINKING OF TEA.

THE HISTORY OF THE CEREMONY IS MORE THAN A THOUSAND YEARS OLD, AND THERE ARE SEVERAL VERSIONS OF IT, ALL OF WHICH ABIDE BY STRICT CODES. DEPENDING ON THE SEASON AND THE TYPE OF CEREMONY, THE UTENSILS EMPLOYED ALSO DIFFER, AS DO SOME ELEMENTS OF THE RITUAL. THE TEA THAT IS SERVED IS *MATCHA*, A POWDERED GREEN TEA. THE FINAL DRINK IS THEREFORE NOT INFUSED: THE GROUND LEAVES REMAIN ON THE SURFACE OF THE WATER AND ARE CONSUMED AT THE SAME TIME.

CONSIDERABLE IMPORTANCE IS ATTACHED TO THE ROOM WHERE THE CEREMONY TAKES PLACE: OFTEN VERY SMALL, IT IS CHARACTERIZED BY A LOW ENTRANCE THAT FORCES YOU TO BOW TO ENTER. ON ONE SIDE OF THE ROOM IS A SLIDING DOOR: AFTER THE GUESTS HAVE SAT DOWN, THIS DOOR OPENS TO REVEAL THE *TEISHU*, THE PERSON WHO WILL MAKE THE TEA... AND THE CEREMONY BEGINS.

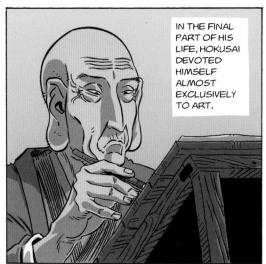

IN THE FINAL PART OF HIS LIFE, HOKUSAI DEVOTED HIMSELF ALMOST EXCLUSIVELY TO ART.

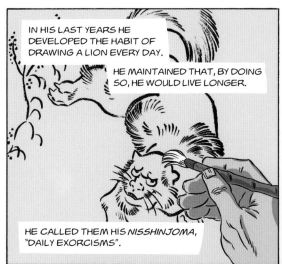

IN HIS LAST YEARS HE DEVELOPED THE HABIT OF DRAWING A LION EVERY DAY.

HE MAINTAINED THAT, BY DOING SO, HE WOULD LIVE LONGER.

HE CALLED THEM HIS *NISSHINJOMA*, "DAILY EXORCISMS".

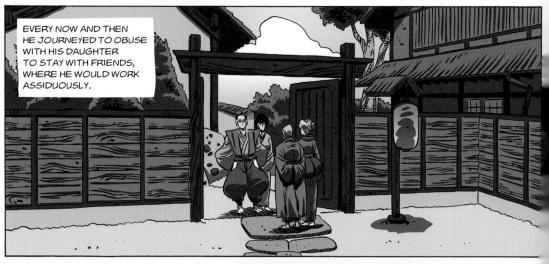

EVERY NOW AND THEN HE JOURNEYED TO OBUSE WITH HIS DAUGHTER TO STAY WITH FRIENDS, WHERE HE WOULD WORK ASSIDUOUSLY.

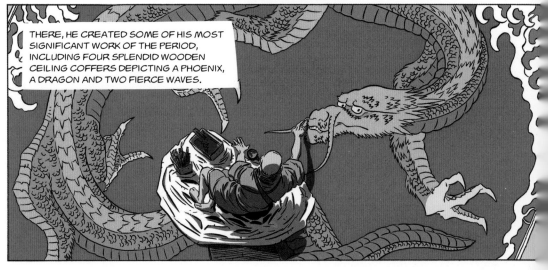

THERE, HE CREATED SOME OF HIS MOST SIGNIFICANT WORK OF THE PERIOD, INCLUDING FOUR SPLENDID WOODEN CEILING COFFERS DEPICTING A PHOENIX, A DRAGON AND TWO FIERCE WAVES.

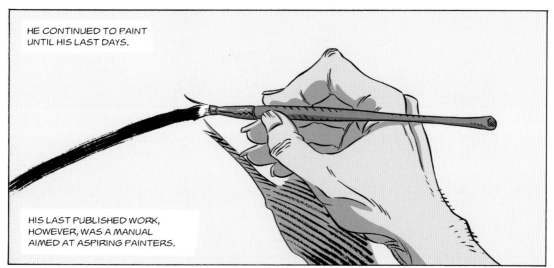

HE CONTINUED TO PAINT
UNTIL HIS LAST DAYS.

HIS LAST PUBLISHED WORK,
HOWEVER, WAS A MANUAL
AIMED AT ASPIRING PAINTERS.

HE DIED ON 10 MAY 1849. IT WAS NOT
LONG INTO THE SECOND YEAR OF THE
KAEI ERA, AND HE WAS 89 YEARS OLD.

IN 1853, ONLY A FEW YEARS AFTER HOKUSAI'S DEATH,
JAPAN WAS FORCED TO END ITS POLICY OF ISOLATION
AND OPEN ITS BORDERS. THE ARRIVAL OF AMERICAN
WARSHIPS UNDER THE COMMAND OF US NAVY COMMODORE
MATTHEW PERRY CAUSED THE COUNTRY'S HISTORY TO TAKE
A SHARP TURN: IN JUST A FEW YEARS, UNDER AMERICAN
PRESSURE, JAPAN SIGNED A SERIES OF TREATIES – BOTH
WITH THE US AND OTHER WESTERN NATIONS – WHICH
DECREED THE END OF ITS CENTURIES OF ISOLATION.

THE FIRST AGREEMENTS, IMPOSED PRACTICALLY BY
FORCE, WERE CONSIDERABLY WEIGHTED IN FAVOUR
OF THE FOREIGN POWERS. SUBSEQUENT TREATIES,
HOWEVER, DRAWN UP OVER THE FOLLOWING DECADES,
ALLOWED THE BALANCE TO BE REDRESSED AND CLARIFIED
THE NATURE OF THE RELATIONSHIPS JAPAN WOULD
HAVE WITH FOREIGN COUNTRIES... WITH IT EVENTUALLY
BECOMING THE ECONOMIC POWER WE KNOW TODAY.

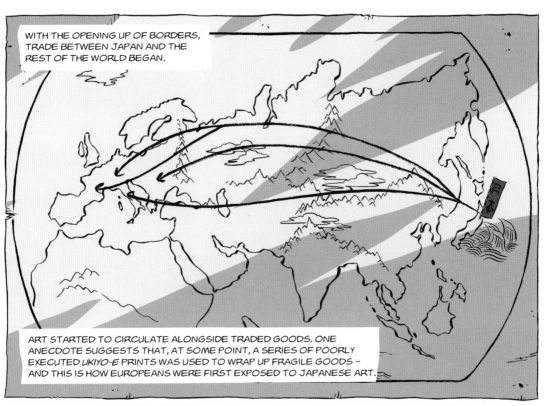

WITH THE OPENING UP OF BORDERS, TRADE BETWEEN JAPAN AND THE REST OF THE WORLD BEGAN.

ART STARTED TO CIRCULATE ALONGSIDE TRADED GOODS. ONE ANECDOTE SUGGESTS THAT, AT SOME POINT, A SERIES OF POORLY EXECUTED *UKIYO-E* PRINTS WAS USED TO WRAP UP FRAGILE GOODS – AND THIS IS HOW EUROPEANS WERE FIRST EXPOSED TO JAPANESE ART.

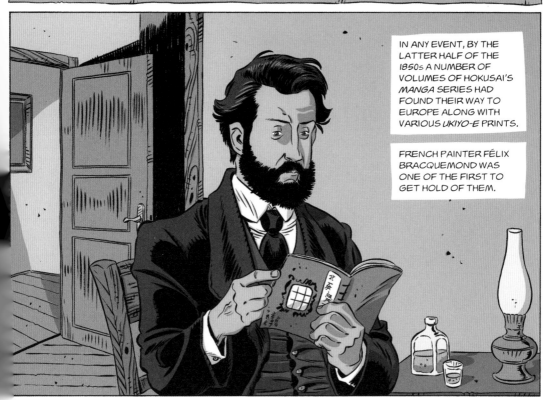

IN ANY EVENT, BY THE LATTER HALF OF THE 1850s A NUMBER OF VOLUMES OF HOKUSAI'S *MANGA* SERIES HAD FOUND THEIR WAY TO EUROPE ALONG WITH VARIOUS *UKIYO-E* PRINTS.

FRENCH PAINTER FÉLIX BRACQUEMOND WAS ONE OF THE FIRST TO GET HOLD OF THEM.

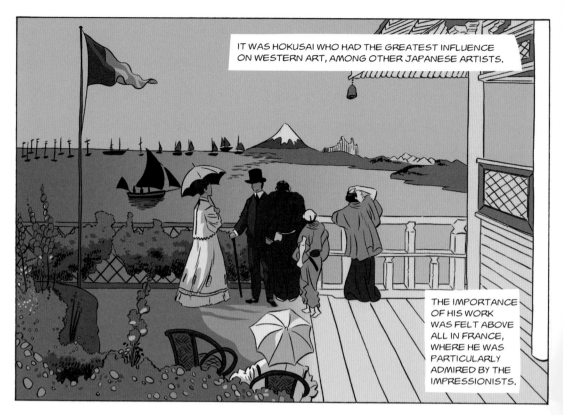

IT WAS HOKUSAI WHO HAD THE GREATEST INFLUENCE ON WESTERN ART, AMONG OTHER JAPANESE ARTISTS.

THE IMPORTANCE OF HIS WORK WAS FELT ABOVE ALL IN FRANCE, WHERE HE WAS PARTICULARLY ADMIRED BY THE IMPRESSIONISTS.

THE ARRIVAL OF JAPANESE ART, SO DIFFERENT FROM WHAT WAS BEING PRODUCED IN EUROPE, AROUSED GREAT INTEREST AND CURIOSITY.

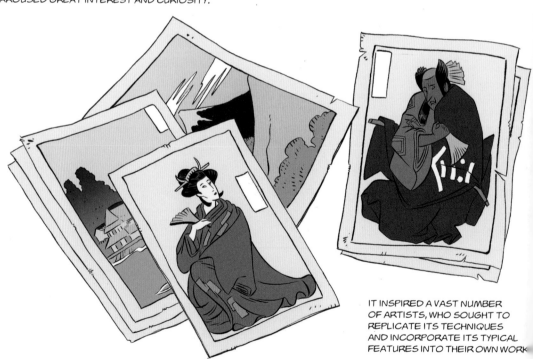

IT INSPIRED A VAST NUMBER OF ARTISTS, WHO SOUGHT TO REPLICATE ITS TECHNIQUES AND INCORPORATE ITS TYPICAL FEATURES INTO THEIR OWN WORK

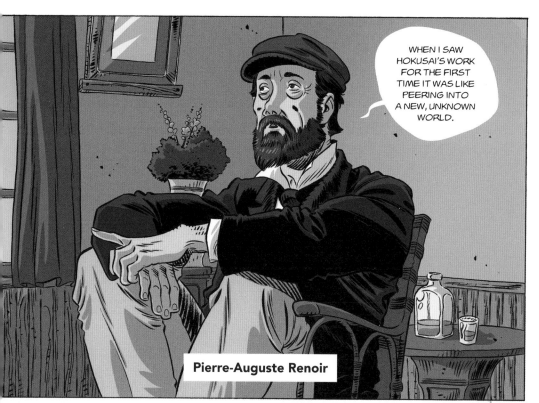

Pierre-Auguste Renoir

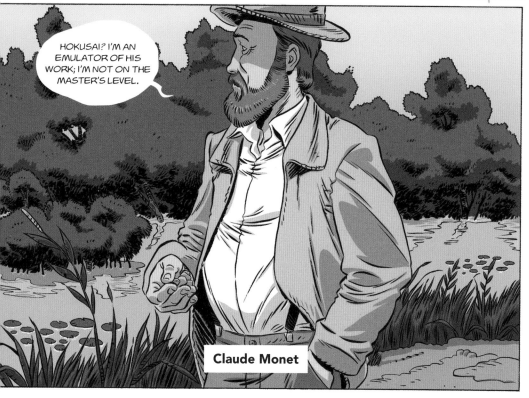

Claude Monet

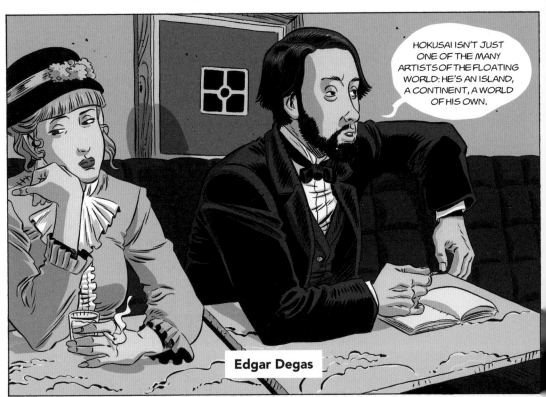

Edgar Degas

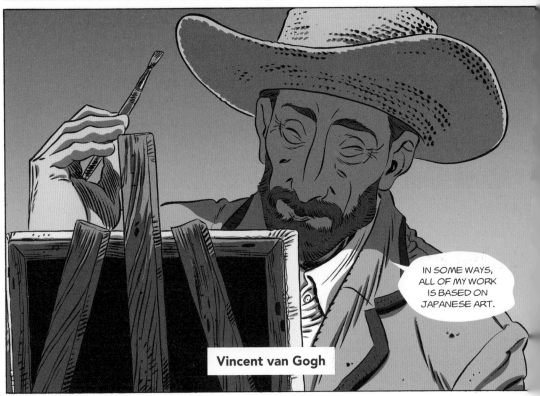

Vincent van Gogh

HOKUSAI'S INFLUENCE ON EUROPEAN CULTURE HAS
BEEN ENORMOUS. IMPRESSIONISM WOULD NOT HAVE
BEEN THE SAME HAD HIS WORK NOT REACHED FRANCE,
BUT HIS IMPORTANCE FOR THE WESTERN CANON DOESN'T
END THERE. ART NOUVEAU, FOR EXAMPLE, ALSO OWES
A GREAT DEAL TO JAPANESE INFLUENCE ALBEIT INDIRECTLY;
EVERYTHING THAT HAS BEEN DERIVED FROM THAT STYLE
BEARS SOMETHING OF HOKUSAI AND JAPAN.

IN 1887, VINCENT VAN GOGH PAINTED A PIECE ENTITLED
JAPONAISERIE, IN WHICH THE REFERENCES TO *UKIYO-E* –
WHETHER IN THE CHOICE OF SUBJECT OR THE
TECHNIQUES USED – ARE CLEAR.

HOKUSAI'S INFLUENCE EVEN FOUND ITS WAY INTO MUSIC:
CLAUDE DEBUSSY WAS INSPIRED BY *UNDER THE GREAT
WAVE OFF KANAGAWA* WHEN WRITING HIS ORCHESTRAL
COMPOSITION, *LA MER*. WHEN THE SCORE WAS PUBLISHED,
IN 1905, ITS FRONT
COVER FEATURED
A MOST EYE-
CATCHING IMAGE.
IT WAS A REWORKING
OF HOKUSAI'S
GREAT WAVE.

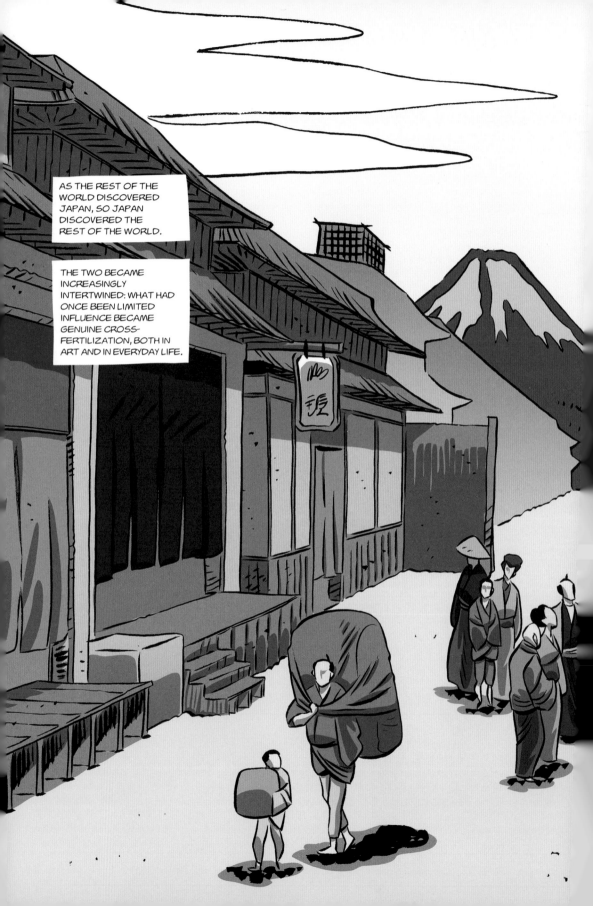

AS THE REST OF THE WORLD DISCOVERED JAPAN, SO JAPAN DISCOVERED THE REST OF THE WORLD.

THE TWO BECAME INCREASINGLY INTERTWINED: WHAT HAD ONCE BEEN LIMITED INFLUENCE BECAME GENUINE CROSS-FERTILIZATION, BOTH IN ART AND IN EVERYDAY LIFE.

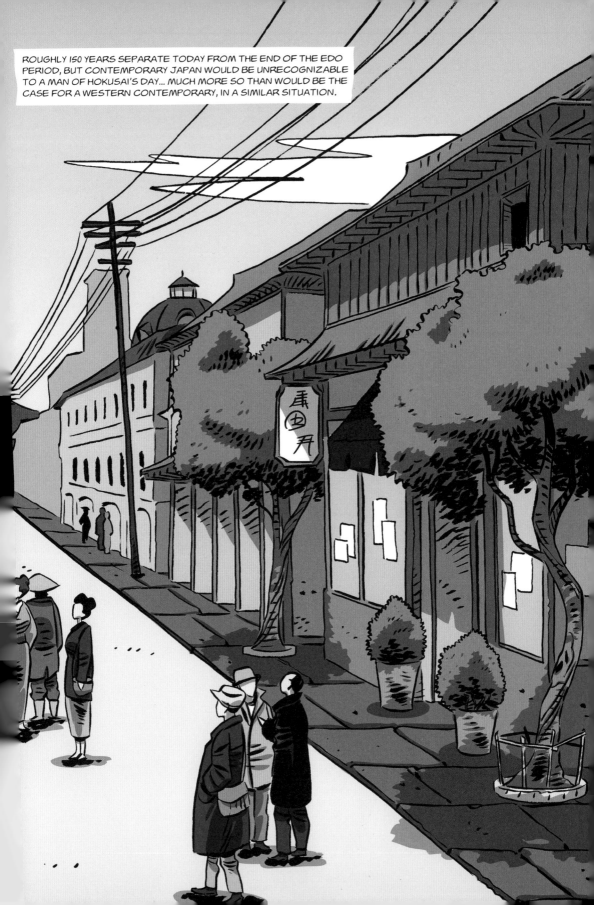

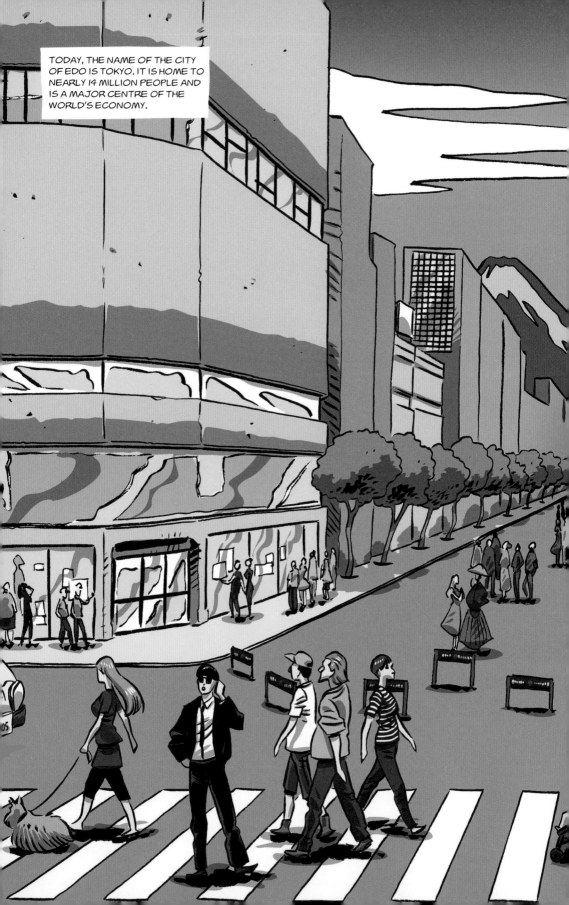

TODAY, THE NAME OF THE CITY OF EDO IS TOKYO. IT IS HOME TO NEARLY 14 MILLION PEOPLE AND IS A MAJOR CENTRE OF THE WORLD'S ECONOMY.

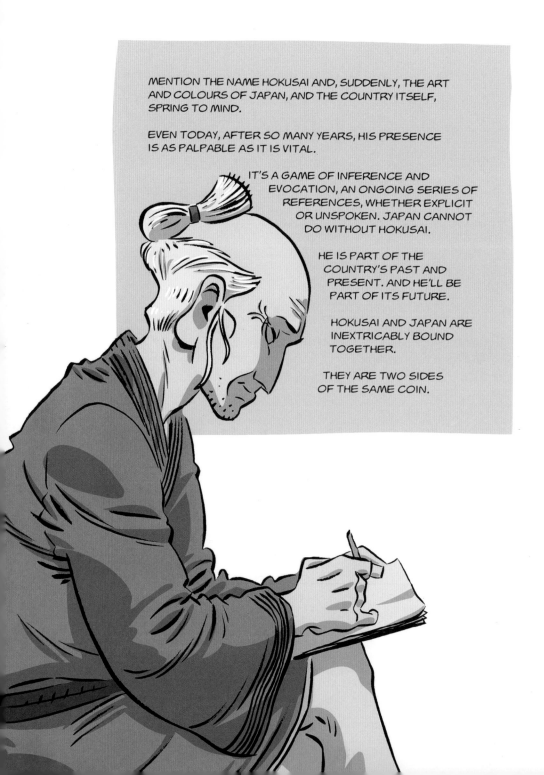

MENTION THE NAME HOKUSAI AND, SUDDENLY, THE ART AND COLOURS OF JAPAN, AND THE COUNTRY ITSELF, SPRING TO MIND.

EVEN TODAY, AFTER SO MANY YEARS, HIS PRESENCE IS AS PALPABLE AS IT IS VITAL.

IT'S A GAME OF INFERENCE AND EVOCATION, AN ONGOING SERIES OF REFERENCES, WHETHER EXPLICIT OR UNSPOKEN. JAPAN CANNOT DO WITHOUT HOKUSAI.

HE IS PART OF THE COUNTRY'S PAST AND PRESENT. AND HE'LL BE PART OF ITS FUTURE.

HOKUSAI AND JAPAN ARE INEXTRICABLY BOUND TOGETHER.

THEY ARE TWO SIDES OF THE SAME COIN.

Afterword

THE APPEAL OF FALSEHOOD

There is a story that, in the early years of the nineteenth century, a noted Kabuki actor by the name of Onoye Baiko sent someone to call for Hokusai. The actor was particularly fond of the artist's work and was very keen to meet him – but Hokusai let the invitation slide without giving it too much thought. Baiko was not to be discouraged, and, as the painter was not proving responsive, he decided to go to the workshop himself to meet him. When he arrived, Hokusai invited him to sit down, but the workshop floor was so dirty that the actor asked if he might have something to sit on. This seemed to irritate and offend the master, who turned his back on Baiko and continued to draw, without speaking another word to him.

It is difficult to establish whether this story really took place or not: Hokusai's behaviour seems a little extreme to be believed without further query. Then again, if we look at what we know of Hokusai, it is a plausible story. And this is where the problems begin, because many of the details we have about Hokusai come from his autobiographical writings, which were then retold by his friends and acquaintances and which, by their very nature, cannot be deemed entirely reliable.

Moreover, as well as being a great artist, Hokusai was also a phenomenal narrator of his own life; he was one of the first examples of the individual becoming a personality, as part of a narrative act in which true, plausibly true and undoubtedly false combine to create a new entity that ultimately manages to be truer than the truth itself.

For instance, it is said that he moved house 93 times in his life. Given that Hokusai died at the age of 90 and that at least for the first part of his life – when he lived with his parents – his existence would not have been as restless as it later became, this number of moves seems a little high. Were the 93 moves true? Or was the number tweaked to make the story more appealing?

Incidentally, researching Hokusai also means dealing with sources that are often contradictory, and which it is difficult to trust entirely. One therefore has to make a selection and decide which episodes appear credible, which are, at the very least, plausible and which are entirely unlikely.

Various sources suggest that the fire that burned down the house in which the artist lived with his daughter played out as follows: Hokusai and his daughter were at home when it happened, and amid the rush to escape the flames the artist had apparently only one concern – to save his brushes. Not his work, nor any other genuinely significant object, but his paintbrushes – tools that wear out quickly and are easily replaced. Then again, thinking about the effect that a story of this kind would have on the listener, what else could the "old man mad about painting" choose to protect?

There are so many stories involving Hokusai that sit on the edge of plausibility; to tell them all would be impossible. To create this book we had to make a selection, leaving out the less significant events and adjusting others to make them less incredible. Actually, there is at least one episode – I won't say which – in the pages you have just read that I would be prepared to bet is completely without foundation. But it was too good to leave out and, what is more, it has become part of the "myth" of Hokusai; omitting it would have been unforgivable.

Nowadays, we are used to the artist–personality who curates their own story as much (if not more) than their work, exactly the way Hokusai did two centuries ago. So, who was Hokusai, then?
A painter and illustrator of rare talent who had an enormous impact on Japanese and international art, but also an artist in a more holistic sense, one able to transform his own life into an immortal artwork.

We don't know whether or not a lot of the stories told about Hokusai are true; but even if they were pure invention – entirely narrative constructions – would that be reason enough to stop telling them?

Francesco Matteuzzi

Drawing Hokusai

When I started working on Hokusai I never would have expected to discover so many parallels with my own life and work: I, too, had an excellent mentor, a long period of cutting my teeth, an existential crisis, and then lots of work and experimentation.

And this final parallel is the one that struck me most, because that's what I did in the making of this book: experiment! I adopted a different, simpler and cleaner style than usual – one typical of the *manga* and prints of the time that I used as reference points – and rigorously inked everything in the traditional way, using a brush and Indian ink, just as the master himself did. The digital colouring, which offers a slight nod to Japanese *anime*, follows a line that marries the new with the traditional, in a working method that I refined board by board, colour by colour, and worry by worry. It is almost as if the book you have in your hands had been made by the master Hokusai himself because it is the result of patience, research and sleepless nights (further parallels!).

I can't deny that drawing Hokusai's life has changed my own drawing style, and how I relate to the pages to be drawn and the brushstrokes to be applied. It's as if the master had passed on his way of thinking to me. Who knows, maybe I too will reach his venerable age and still be drawing at 90 years old…

Giuseppe Latanza

Bibliography

Jocelyn Bouquillard, *Le trentasei vedute del monte Fuji* (*The Thirty-Six Views of Mount Fuji*), L'Ippocampo 2010

Timothy James Clark (ed.), *Hokusai: Beyond the Great Wave*, Thames & Hudson Ltd 2017

Henri Focillon, *Hokusai*, Abscondita 2003

Iseki Masaaki, *Pittura giapponese dal 1800 al 2000* (*Japanese Painting from 1800 to 2000*), Skira 2001

Francesco Morena, *Arte giapponese* (*Japanese Art*), Giunti 2017

Francesco Morena, *Hokusai*, Giunti 2015

Rhiannon Paget, *Hokusai*, Taschen 2018

Documentaries

Visite à Hokusai, by Jean-Pierre Limosin, 2014

British Museum presents: Hokusai (original title: *Hokusai: Old Man Crazy to Paint*), by Patricia Wheatley, 2017

Acknowledgements

Thank you so much to everyone who worked on this book, particularly Giuseppe Latanza (what a pleasure to work together again!), Marco Ficarra from Studio Ram (without whom it would never have seen the light) and Silvia Pastorino (for the splendid graphic work and for putting up with our moods). It's been an amazing journey.

And thank you, dear reader, for getting this far. We hope to have been worthy of your trust!

Francesco Matteuzzi

None of this would have been possible if Marco Ficarra hadn't offered me the project, or if Francesco Matteuzzi hadn't written an excellent script, and then accepted the odd change from me here and there. Or without the constant support of my family and girlfriend, my finest critic.

And thank you for buying, reading (including these couple of lines) and enjoying this book!

Giuseppe Latanza

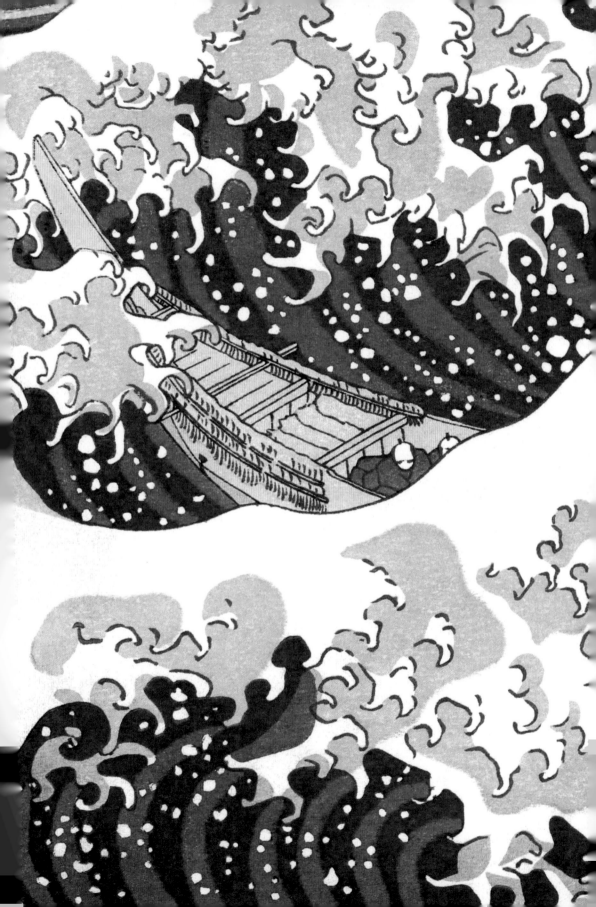

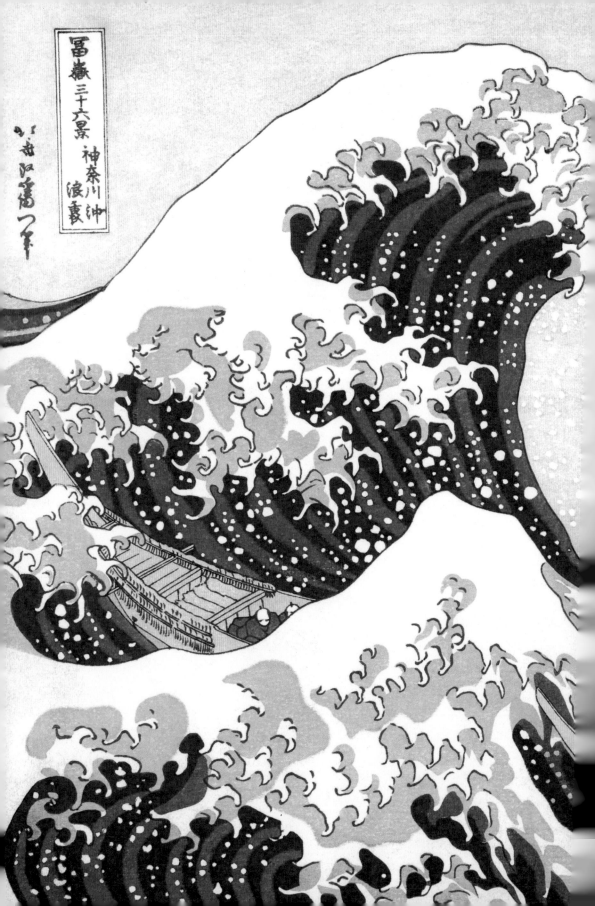